ART OF COLORING

Walt Disney World

100 IMAGES TO INSPIRE CREATIVITY
FROM THE MOST MAGICAL PLACE ON EARTH

For Wes, Evie, Reneé, Josie, Conor, and Gianna

I hope you all grow to appreciate the beauty that surrounds and love that binds. May the call of adventure be your compass and imagination your palette. Life is your canvas! Fill it as you wish—inside the lines or out of the box—your creativity will make the world a better place.

The following are some of the trademarks, registered marks, and service marks owned by Disney Enterprises, Inc.: Aulani, A Disney Resort & Spa; *Adventureland*® Area; *Audio-Animatronics*® Figure; *Disney Springs*™; *Disneyland*® Park; *Disneyland*® Resort; *Disney's Animal Kingdom*® Theme Park; Disney's Contemporary Resort; Disney's Grand Floridian Resort & Spa; *Disney's Hollywood Studios*®; Disney's Polynesian Resort; *EPCOT*®; *Fantasyland*® Area; *Frontierland*® Area; Imagineering; Imagineers; "it's a small world," *It's A Small World*® Attraction; *Magic Kingdom*® Park; *Main Street, U.S.A.*® Area; *Space Mountain*® Attraction; *Tomorrowland*® Area; *Walt Disney World*® Resort; and World Showcase.

Marvel characters and artwork © Marvel.

Pixar properties © Disney/Pixar.

Slinky Dog © POOF Slinky LLC.

Star Wars and Indiana Jones © & TM Lucasfilm Ltd. All Rights Reserved.

Ephemera image captures by Jennifer Eastwood © 2021 Jennifer Eastwood.

Ephemera image captures by Kevin M. Kern © 2021 Kevin M. Kern.

Published by Disney Editions, an imprint of Buena Vista Books, Inc. No part of this book may be reproduced or transmitted in any form or by any means, electronic or mechanical, including photocopying, recording, or by any information storage and retrieval system, without written permission from the publisher. For information address Disney Editions, 77 W. 66th Street, New York, New York 10023.

Editorial Director: Wendy Lefkon • **Senior Editor:** Jennifer Eastwood • **Senior Designer:** Lindsay Broderick
Managing Editor: Monica Vasquez • **Production:** Jerry Gonzalez and Marybeth Tregarthen

ISBN 978-1-368-07798-9
FAC-034274-22287

Printed in the United States of America

First Edition, September 2021
10 9 8 7 6 5 4

THE OFFICIAL Disney FAN CLUB

Visit www.disneybooks.com

ART OF COLORING

Walt Disney World

100 IMAGES TO INSPIRE CREATIVITY
FROM THE MOST MAGICAL PLACE ON EARTH

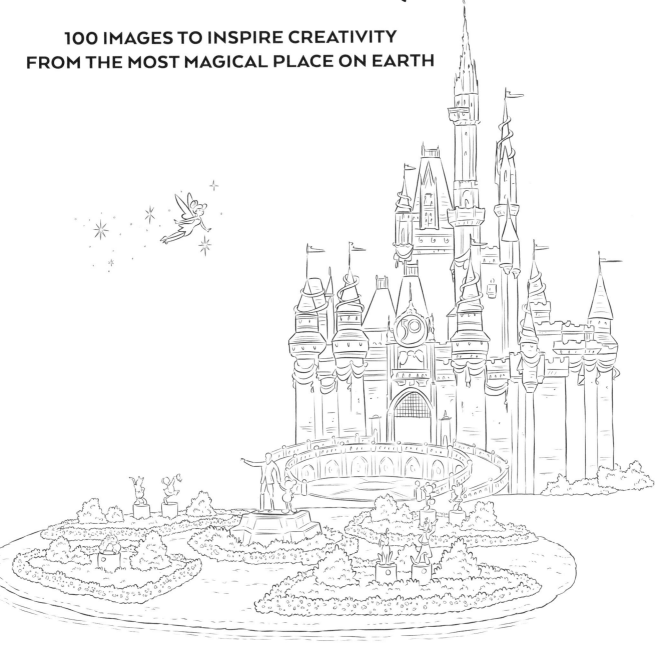

KEVIN M. KERN | Original cover art by **FABIOLA GARZA**

EDITIONS

Los Angeles • New York

Color 1's one color, and color 2's another color.

ABOVE: Color by numbers, *Mickey's Busy Book*, c. 1986.

CONTENTS

PREFACE

THE VERY CONCEPT OF WHAT "CREATIVITY" IS—or what it *can* be—amounts to a great many things to each of us. Colors. Patterns. Mediums. Each is a tool at the behest of the artist within, ready to help employ perhaps the most precious of humanity's gifts—imagination. When confronted with a blank canvas, sheet of paper, sidewalk, bedroom wall—or any surface, really—one thing unites us in our artistic journey: the decision to adventure forward and make our first mark.

> Every child is born blessed with a vivid imagination.
>
> —Walt Disney[P.1]

For me, the Walt Disney World Resort has always been one of those inspirational instigators. Serving as a seemingly endless source of brilliance from which we can draw to not only help make sense of the world around us, but to move ourselves to bring some of its creative magic home, this happy place is a true wellspring of innovation that is capable of imparting joy and new knowledge on any who visit.

The coloring pages we've pulled together in this book come from a variety of historical sources that dot the resort's now half-century legacy, including a few vintage publications that I collected as a child. Many pieces trigger distinct memories of feverishly doodling away to my heart's content while camping with my family at Disney's Fort Wilderness Resort & Campground. These fleeting moments are representative not of bygone days, but of a beloved temporal space deep in our souls that's always only moments away.

OPPOSITE: Resort compass art, 1971.

Above all, I hope you find the same beacon of inspiration our creative team did in pulling these pages together for you. Use pencils, crayons, paint; you name it. I pray you make the following pages *yours*. There's nothing holding you back from covering them with the wildest, craziest, and most remarkable creations yet. May your creative compass help guide the artistic adventures that lie ahead within these views, these snapshots, these memories of our grand muse, The Most Magical Place on Earth: Walt Disney World.

Kevin M. Kern

Kevin M. Kern
June 2021

ABOVE: Original cover art by Fabiola Garza, created for *A Portrait of Walt Disney World: 50 Years of The Most Magical Place on Earth*, 2021.

NOSTALGIA
AN IDEALIZED YESTERYEAR

> Our heritage and ideals, our
> code and standards—the
> things we live by and teach
> our children—are preserved
> or diminished by how freely we
> exchange ideas and feelings.
>
> —Walt Disney[N.1]

STEEPED IN THE YEARNING FOR AN IDYLLIC TIME gone by—
or that never was!—a rich sense of nostalgia informs
many of the experiences that exist at Walt Disney World.
Imbued with a *feeling* that is meant to reassure all who visit,
you're bound to find a fulfilling, optimistic adventure that also
reminds you of a familiar sense of belonging. What Walt and Roy
O. Disney envisioned with their Vacation Kingdom was a place
that entertained as well as reassured. Marty Sklar, a longtime
Walt Disney Imagineering creative executive and Disney Legend,
outlined the understanding of this communal, harmonious intent:
"As a visitor, you know where you are, and every detail reinforces
the time period and the experience. Even though you have never
been there, somehow you and your family are at home here."[N.2]
Just as the sands of time are ever shifting, pangs of nostalgia for
the resort are united via one simple constant: afterward, we all
seek to relive the joy and magic we encounter during our visit.
And, as a result, those memories are what help call us back,
time and time again.

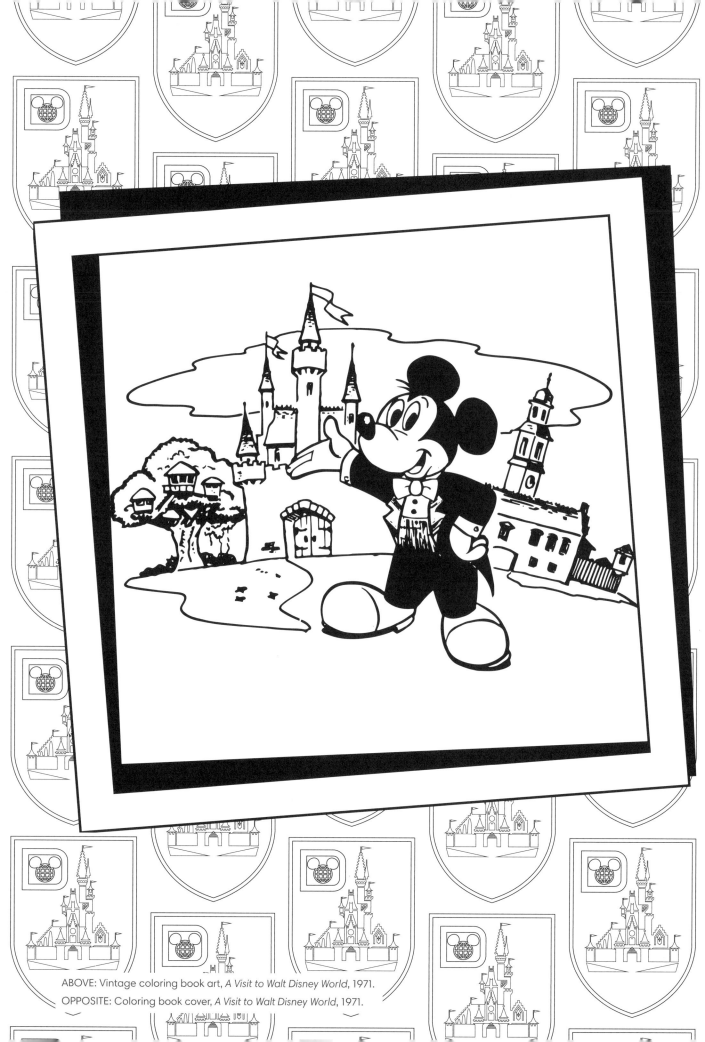

ABOVE: Vintage coloring book art, *A Visit to Walt Disney World*, 1971.

OPPOSITE: Coloring book cover, *A Visit to Walt Disney World*, 1971.

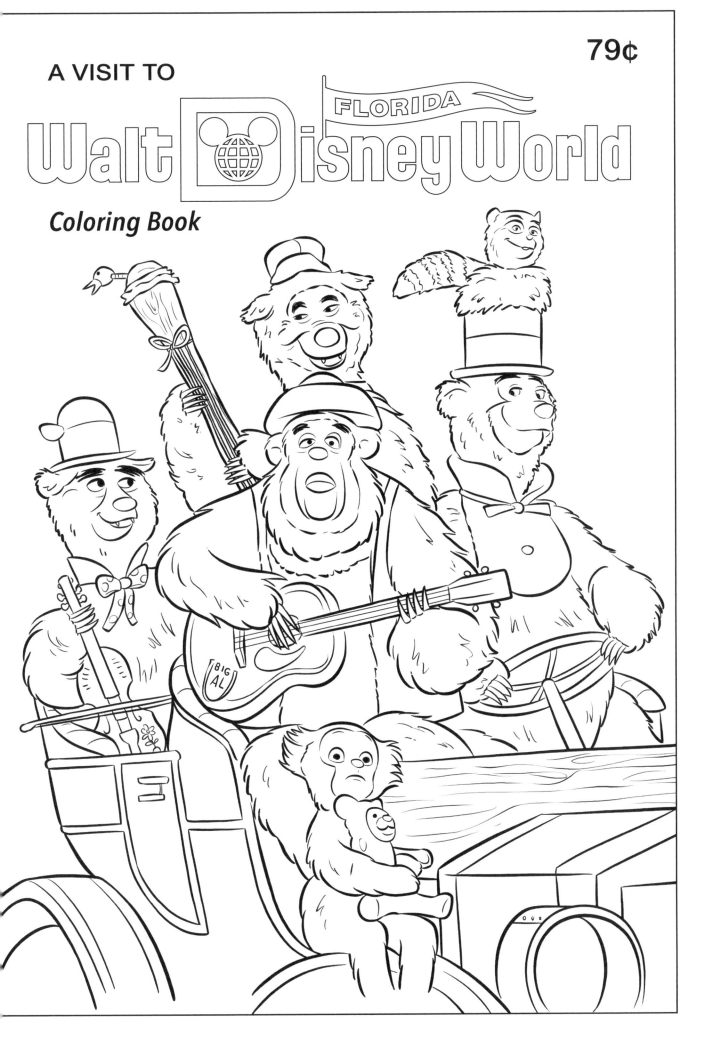

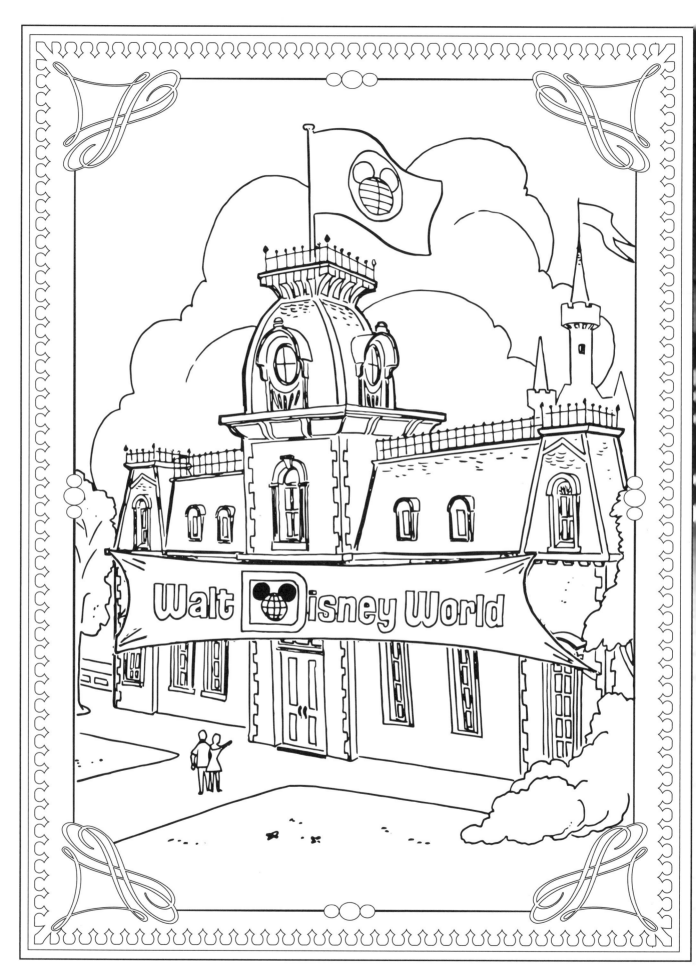

ABOVE: Vintage coloring book art, *A Visit to Walt Disney World*, 1971.

OPPOSITE: Vintage coloring book art, *A Big Coloring Book: Walt Disney World*, 1983.

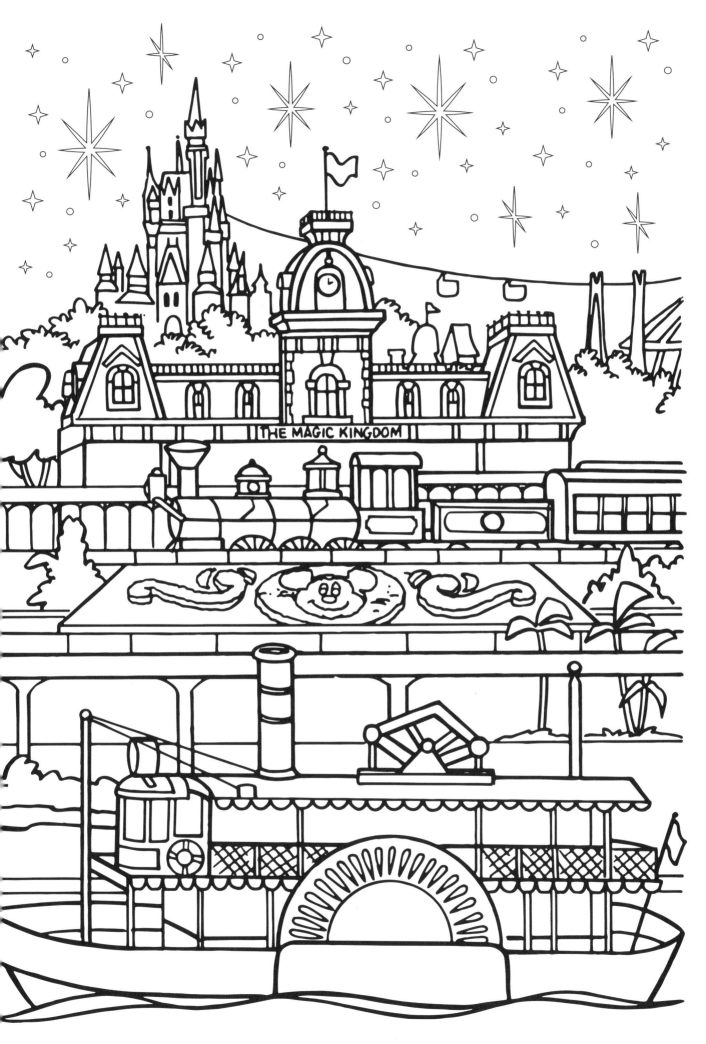

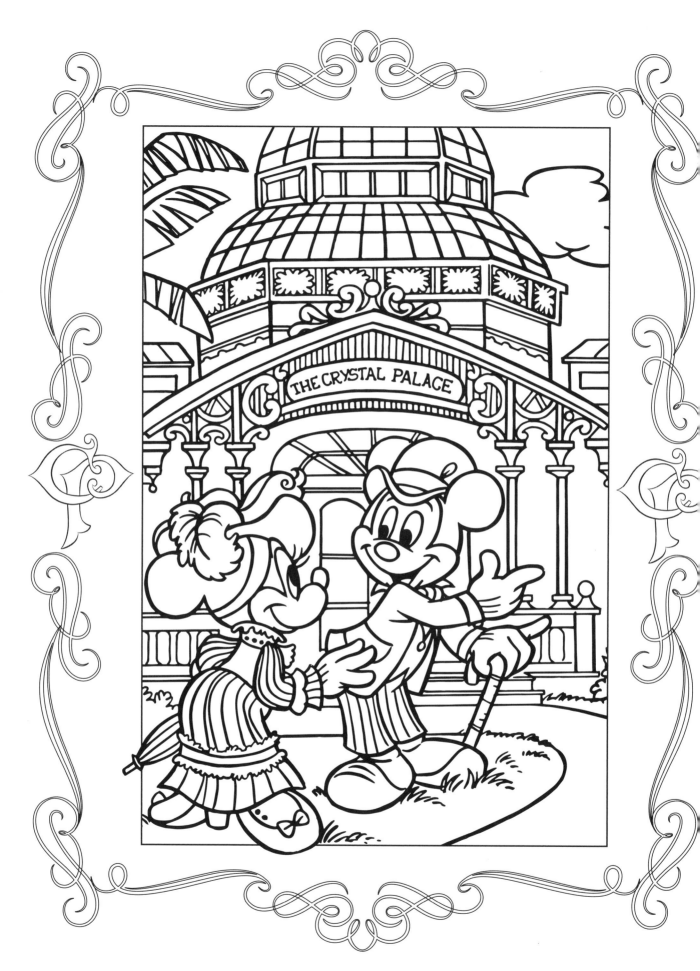

ABOVE AND OPPOSITE: Crystal Palace at the Magic Kingdom. Vintage coloring book art, *A Big Coloring Book: Walt Disney World*, 1983, and frame graphics by Joe Warren, 2002 (above). Attraction poster sketch by Julie Svendsen, 1980 (opposite).

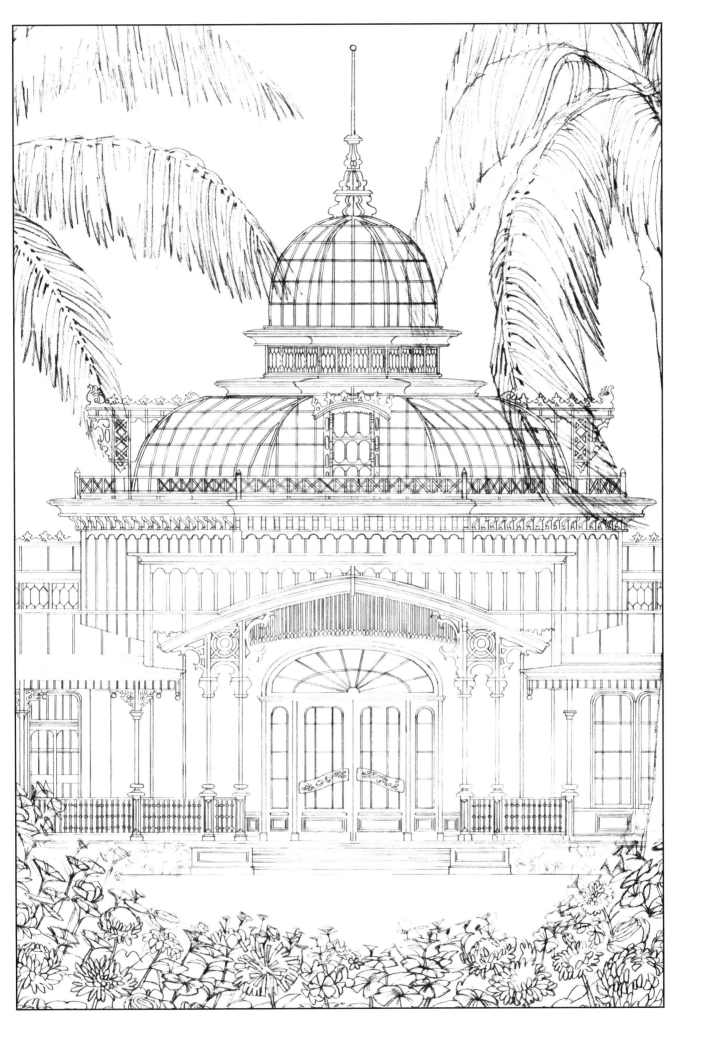

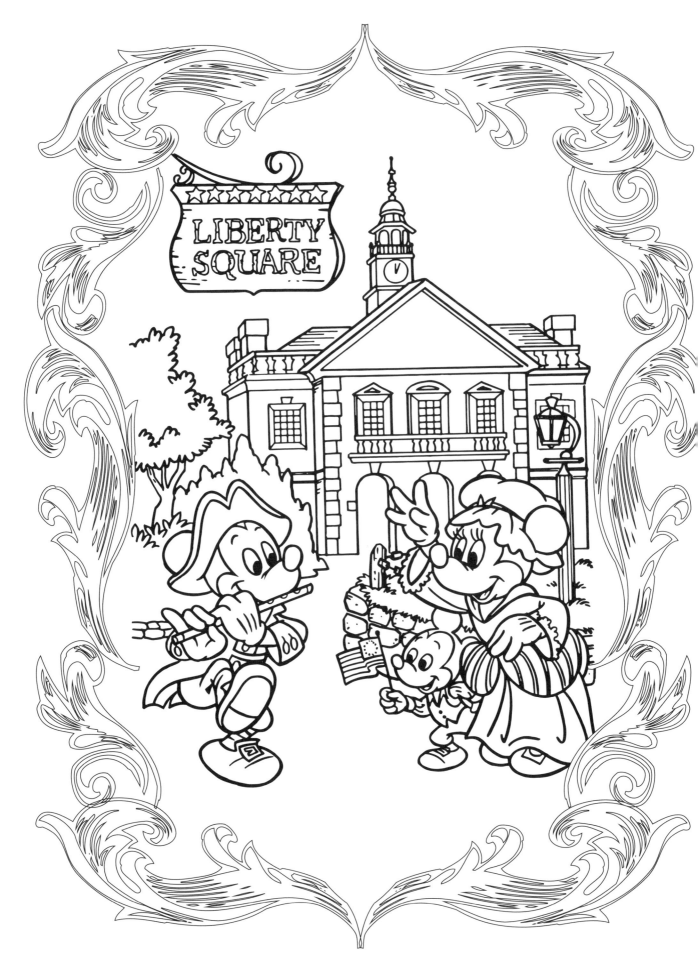

ABOVE: Liberty Square at the Magic Kingdom. Vintage coloring book art, *A Big Coloring Book: Walt Disney World*, 1983.

OPPOSITE: The American Adventure pavilion at EPCOT. Vintage coloring book art, *A Coloring Book: Walt Disney World EPCOT Center*, 1983.

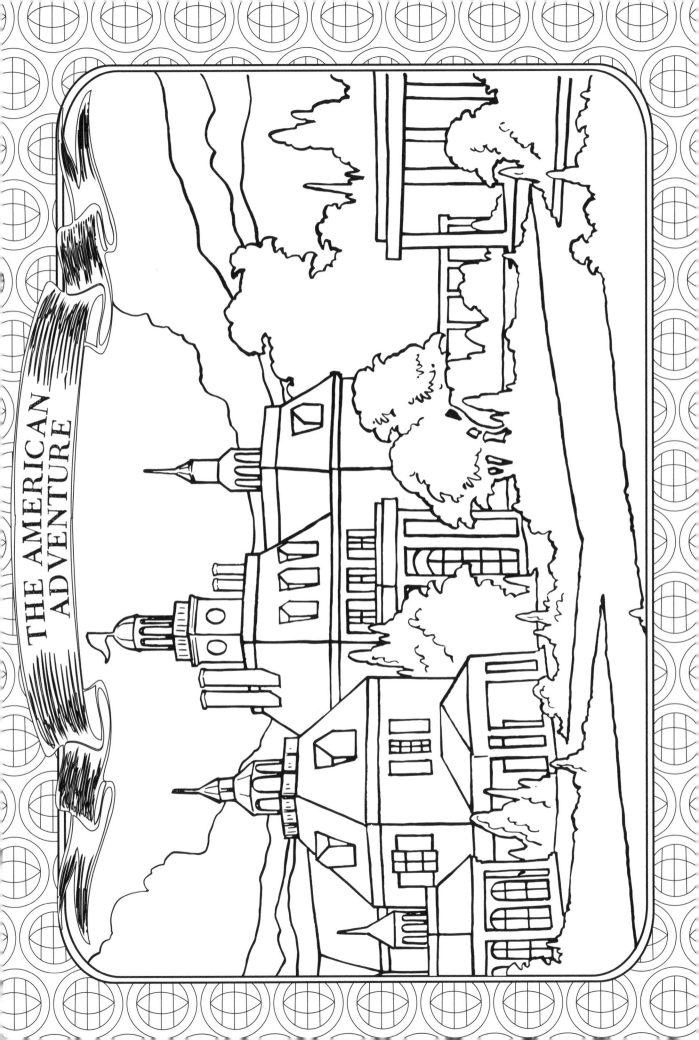

THE AMERICAN ADVENTURE

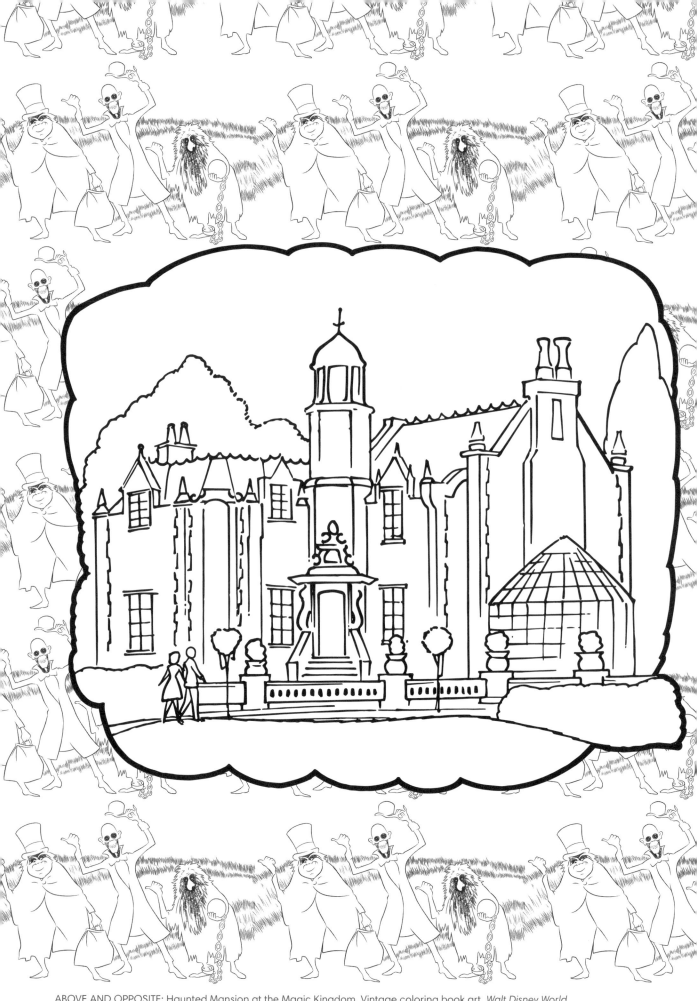

ABOVE AND OPPOSITE: Haunted Mansion at the Magic Kingdom. Vintage coloring book art, *Walt Disney World Coloring Book*, 1972 (above). Attraction poster by Ken Chapman and Marc Davis, 1971 (pattern and opposite).

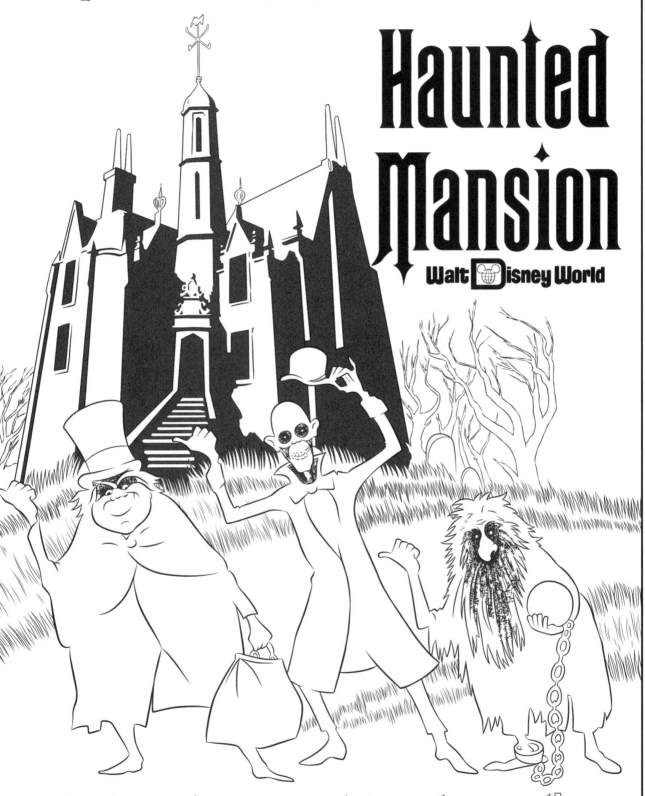

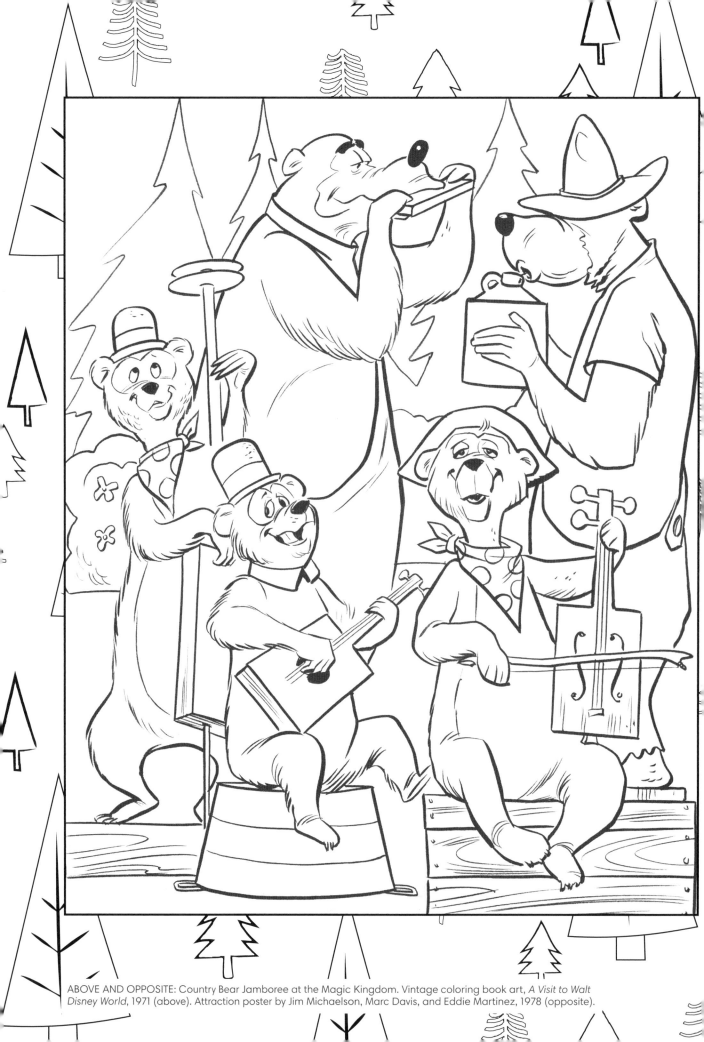

ABOVE AND OPPOSITE: Country Bear Jamboree at the Magic Kingdom. Vintage coloring book art, *A Visit to Walt Disney World*, 1971 (above). Attraction poster by Jim Michaelson, Marc Davis, and Eddie Martinez, 1978 (opposite).

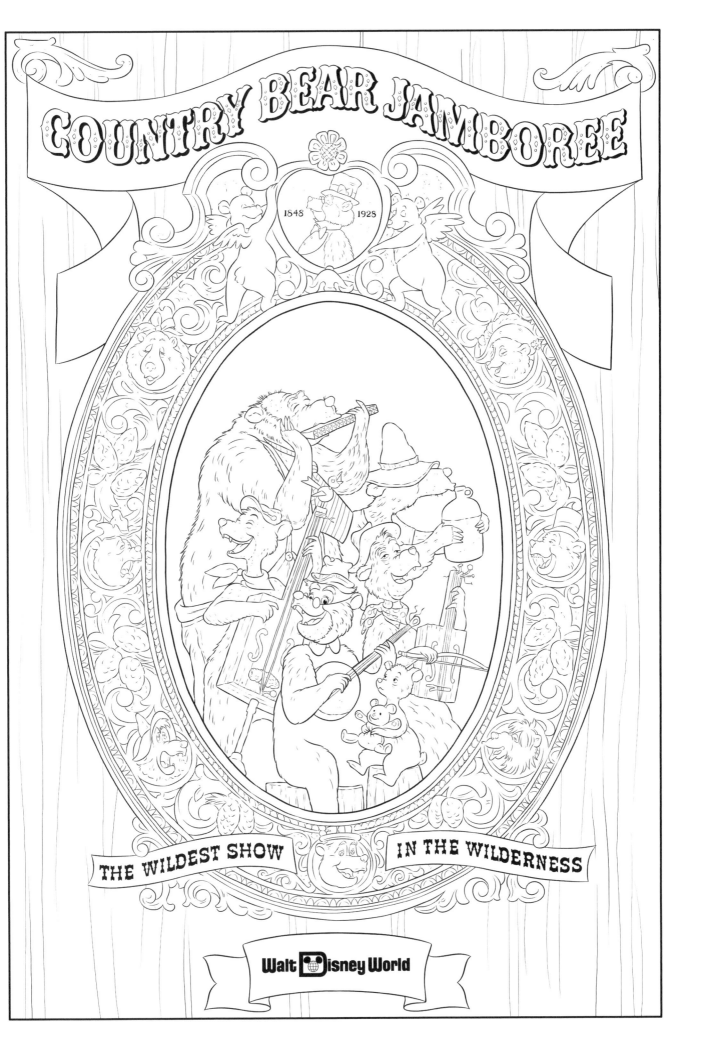

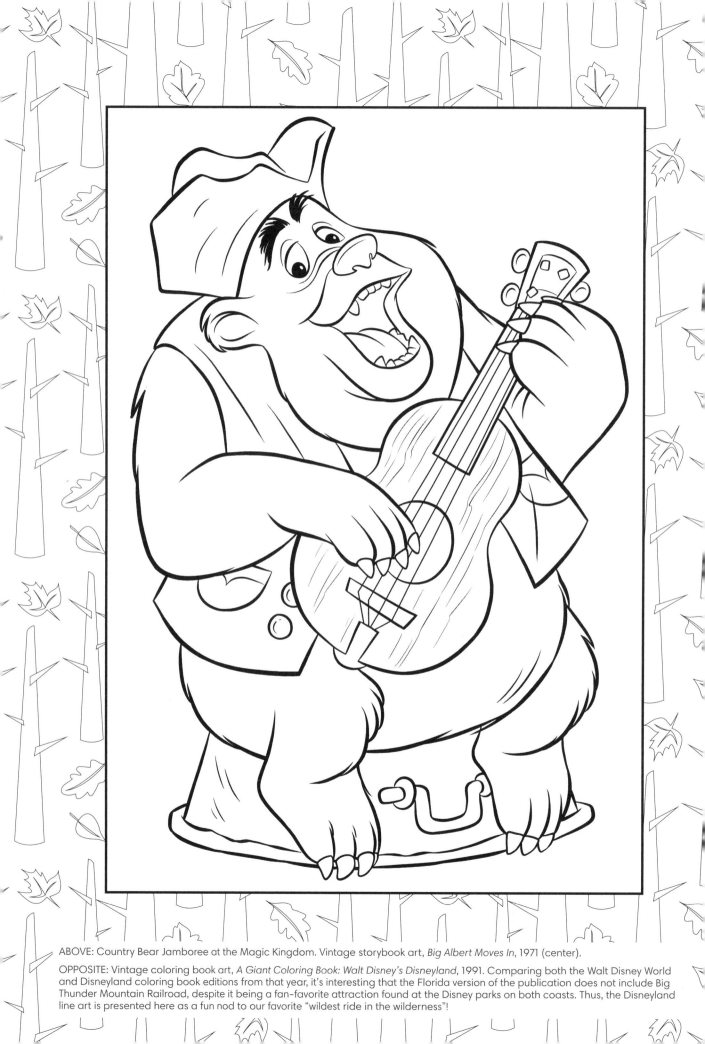

ABOVE: Country Bear Jamboree at the Magic Kingdom. Vintage storybook art, *Big Albert Moves In*, 1971 (center).

OPPOSITE: Vintage coloring book art, *A Giant Coloring Book: Walt Disney's Disneyland*, 1991. Comparing both the Walt Disney World and Disneyland coloring book editions from that year, it's interesting that the Florida version of the publication does not include Big Thunder Mountain Railroad, despite it being a fan-favorite attraction found at the Disney parks on both coasts. Thus, the Disneyland line art is presented here as a fun nod to our favorite "wildest ride in the wilderness"!

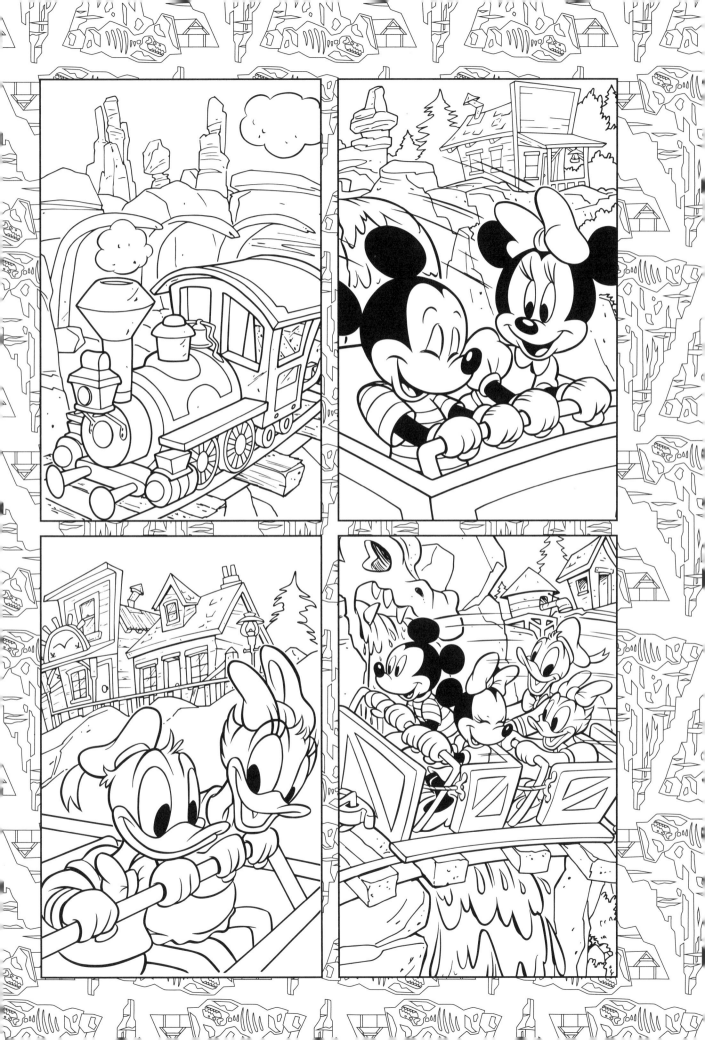

OPPOSITE: Original park map for what is now Disney's Hollywood Studios, 1989.

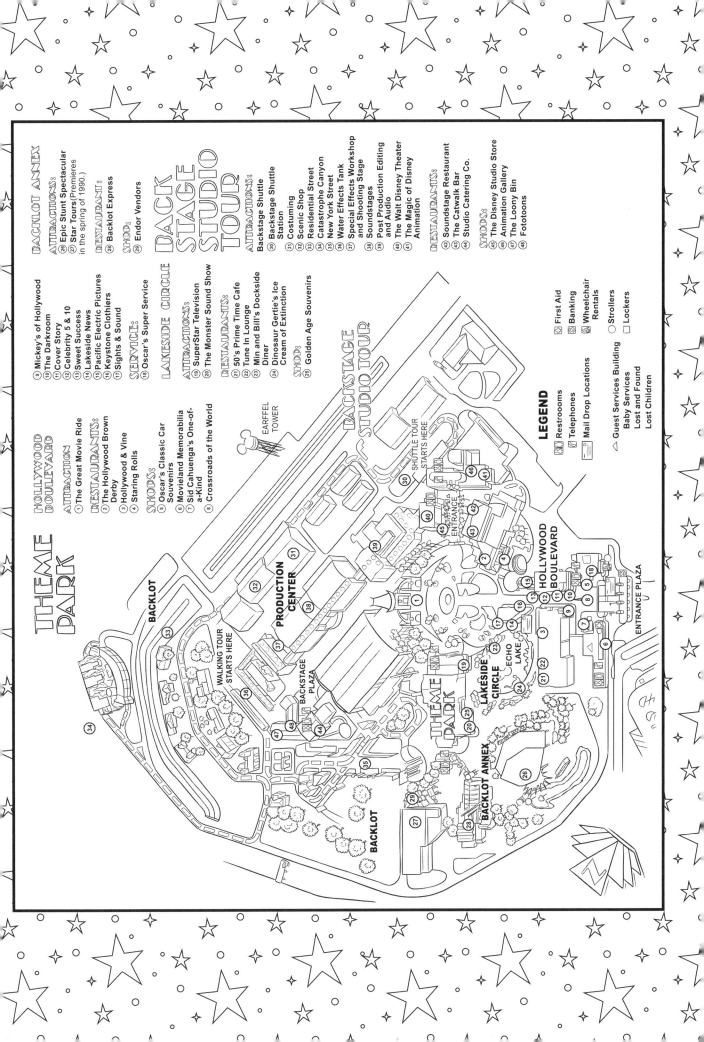

THEME PARK

HOLLYWOOD BOULEVARD

ATTRACTION:
① The Great Movie Ride

RESTAURANTS:
② The Hollywood Brown Derby
③ Hollywood & Vine
④ Staring Rolls

SHOPS:
⑤ Oscar's Classic Car Souvenirs
⑥ Movieland Memorabilia
⑦ Sid Cahuenga's One-of-a-Kind
⑧ Crossroads of the World

⑨ Mickey's of Hollywood
⑩ The Darkroom
⑪ Cover Story
⑫ Celebrity 5 & 10
⑬ Sweet Success
⑭ Lakeside News
⑮ Pacific Electric Pictures
⑯ Keystone Clothiers
⑰ Sights & Sound

SERVICE:
⑱ Oscar's Super Service

LAKESIDE CIRCLE

ATTRACTIONS:
⑲ SuperStar Television
⑳ The Monster Sound Show

RESTAURANTS:
㉑ 50's Prime Time Cafe
㉒ Tune In Lounge
㉓ Min and Bill's Dockside Diner
㉔ Dinosaur Gertie's Ice Cream of Extinction

SHOP:
㉕ Golden Age Souvenirs

BACKLOT ANNEX

ATTRACTIONS:
㉖ Epic Stunt Spectacular
㉗ Star Tours (Premieres in the spring of 1990.)

RESTAURANT:
㉘ Backlot Express

SHOP:
㉙ Endor Vendors

BACK STAGE STUDIO TOUR

ATTRACTIONS:
Backstage Shuttle
㉚ Backstage Shuttle Station
㉛ Costuming
㉜ Scenic Shop
㉝ Residential Street
㉞ Catastrophe Canyon
㉟ New York Street
㊱ Water Effects Tank
㊲ Special Effects Workshop and Shooting Stage
㊳ Soundstages
㊴ Post Production Editing and Audio
㊵ The Walt Disney Theater
㊶ The Magic of Disney Animation

RESTAURANTS:
㊷ Soundstage Restaurant
㊸ The Catwalk Bar
㊹ Studio Catering Co.

SHOPS:
㊺ The Disney Studio Store
㊻ Animation Gallery
㊼ The Loony Bin
㊽ Fototoons

LEGEND
🚹🚺 Restrooms
☎ Telephones
✉ Mail Drop Locations

✚ First Aid
🏦 Banking
♿ Wheelchair Rentals

○ Strollers
☐ Lockers

△ Guest Services Building
Baby Services
Lost and Found
Lost Children

EARFFEL TOWER

SHUTTLE TOUR STARTS HERE

BACKSTAGE STUDIO TOUR

PRODUCTION CENTER

WALKING TOUR STARTS HERE

BACKSTAGE PLAZA

THEME PARK

BACKLOT

LAKESIDE CIRCLE

ECHO LAKE

BACKLOT ANNEX

BACKLOT

HOLLYWOOD BOULEVARD

ENTRANCE PLAZA

ENTRANCE

FANTASY
THE ART OF MAKE-BELIEVE

Fantasy, if it's really convincing,
can't become dated, for the
simple reason that it represents
a flight into a dimension that lies
beyond the reach of time.

—Walt Disney[F.1]

DEDICATED TO THE YOUNG, AND YOUNG AT HEART, the many realms of fantasy that enchant across Walt Disney World represent the innate understanding that *imagination* is the most important part of *being*. With a dream, a wish, and a hearty dose of "what if," the resort provides a potent escapist mixture ripe for the makings of a one-of-a-kind experience, one that places us all in the middle of the magical action. Pam Rawlins, executive producer, Walt Disney Imagineering, outlines the related goal of Imagineers thusly: "We are inviting our guests to step into these worlds of fantasy. It's no longer something you experience passively on a screen. It's living art, and you become the center of the story."[F.2]

When embraced liberally, these fantastical worlds open up doorways for all to pass through—from the top of the tallest castle spire to the bottom of the deepest blue sea—encouraging us to enjoy the art of play, the power of imagination, and the joys of contemplating what could be. When working in concert, these reflections amount to that which The Most Magical Place on Earth does best: making dreams come true.

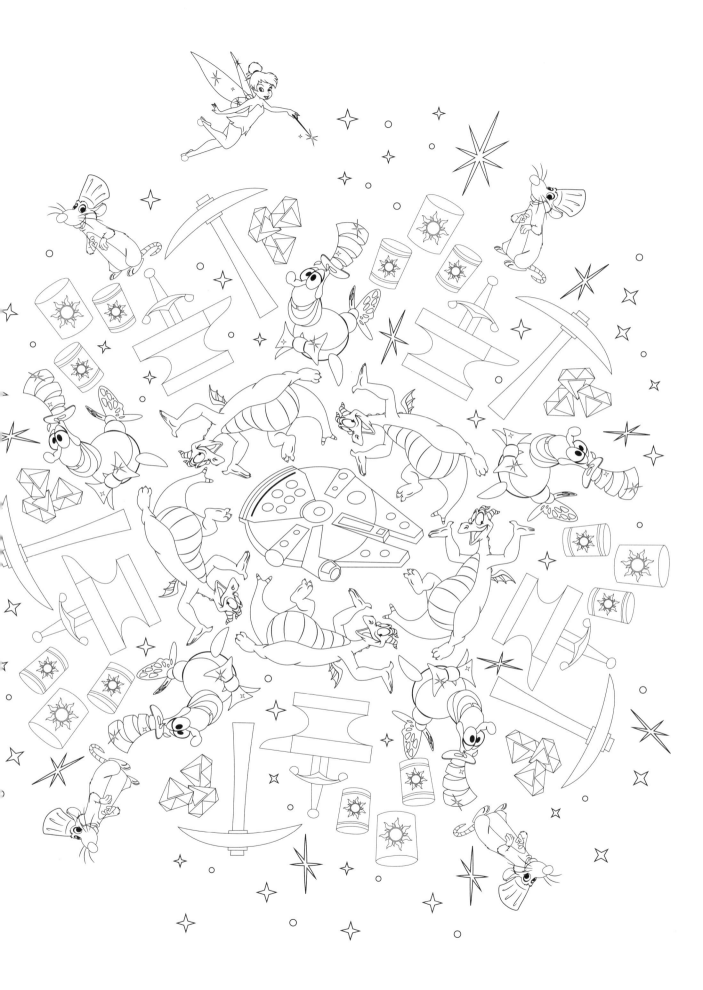

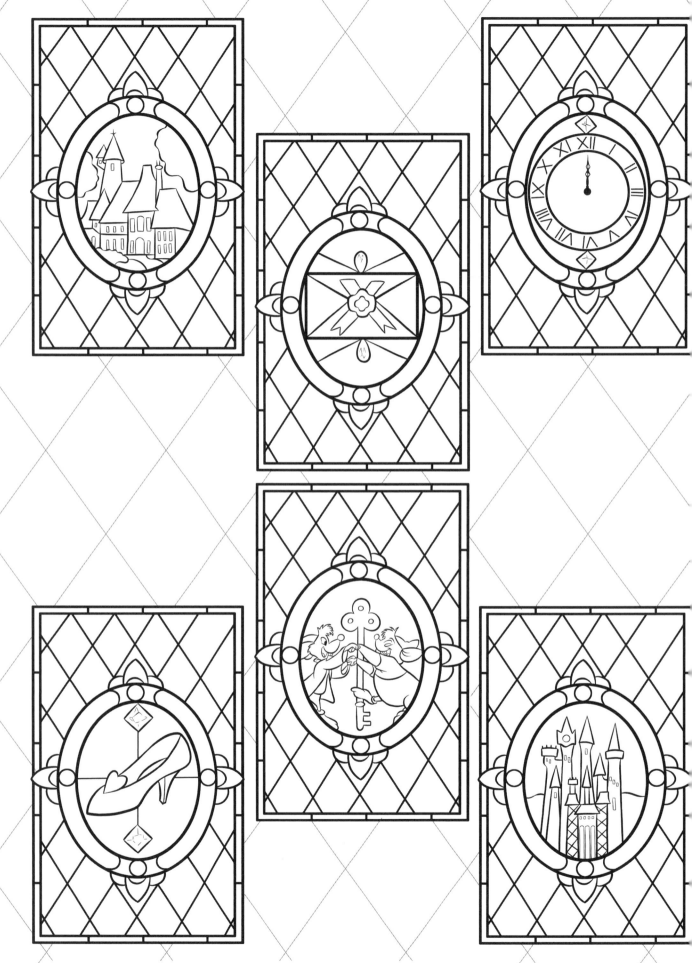

ABOVE AND OPPOSITE: Cinderella Castle at the Magic Kingdom. Stained glass window details, Cinderella Castle Suite, 2007 (above). Color board line art by Debbie Miller, 1997 (opposite).

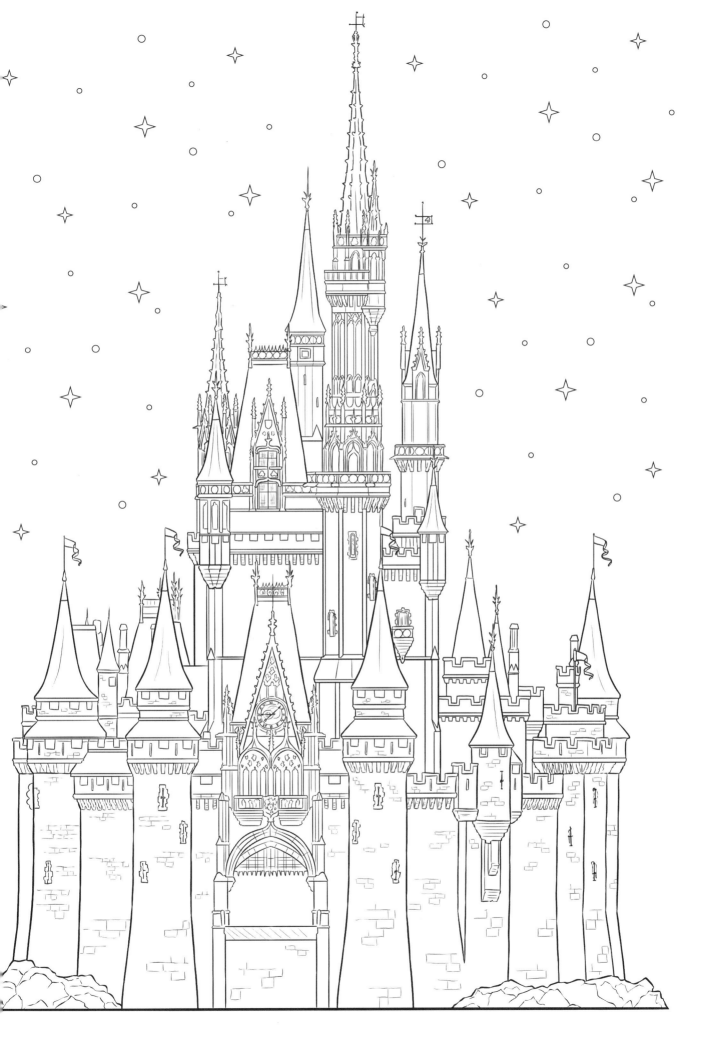

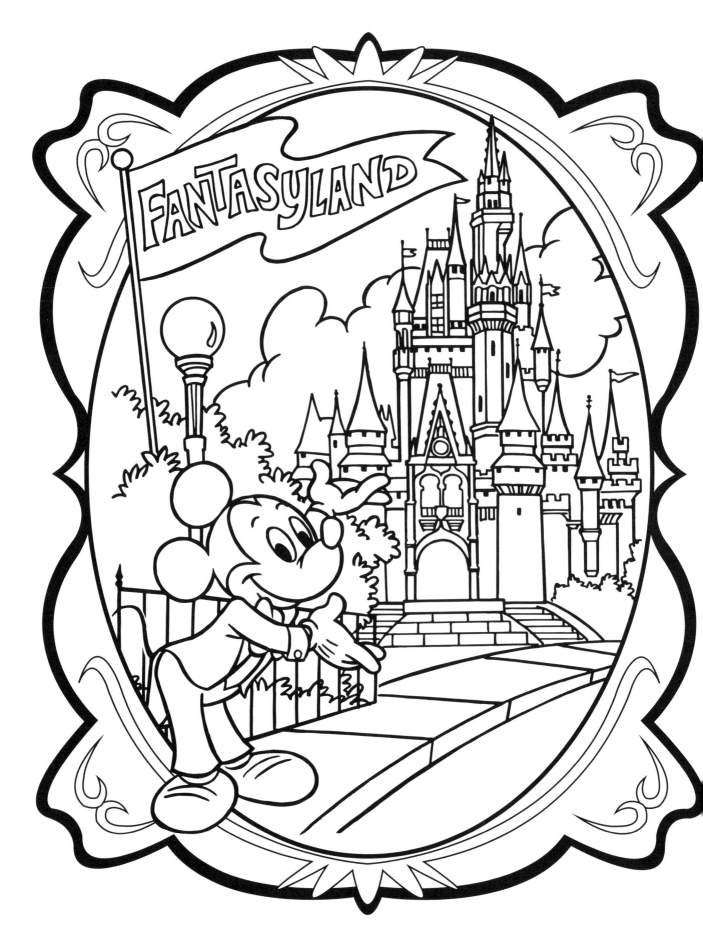

ABOVE: Vintage coloring book art, *A Big Coloring Book: Walt Disney World*, 1983.

OPPOSITE: Mickey Mouse Revue formerly at the Magic Kingdom. Vintage coloring book art, *A Visit to Walt Disney World*, 1971.

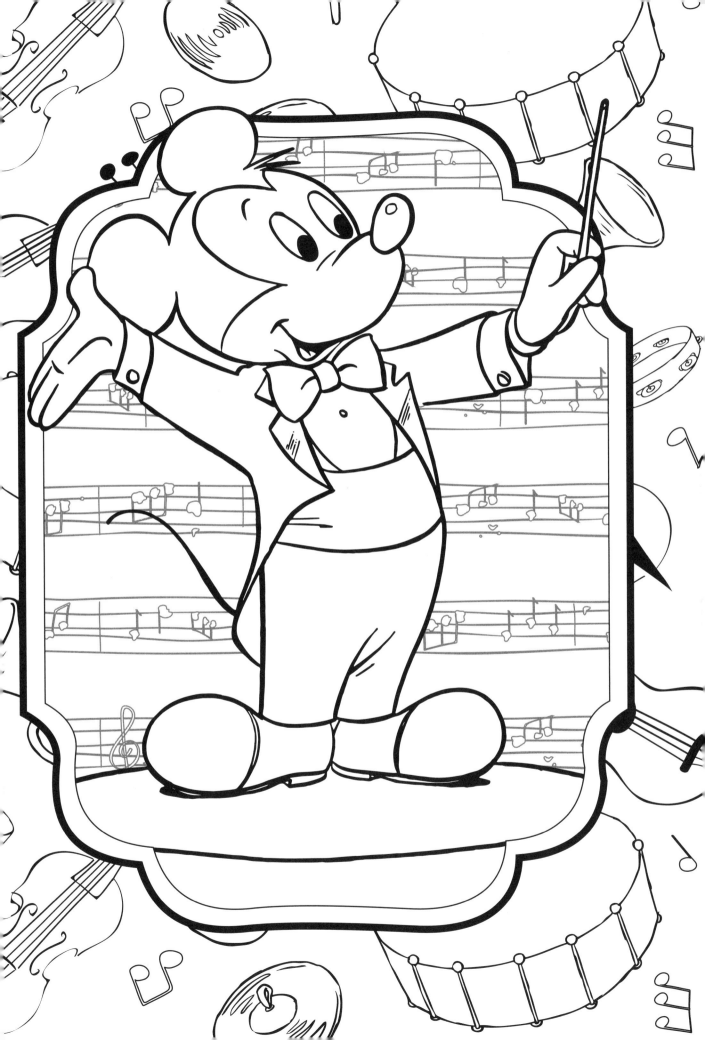

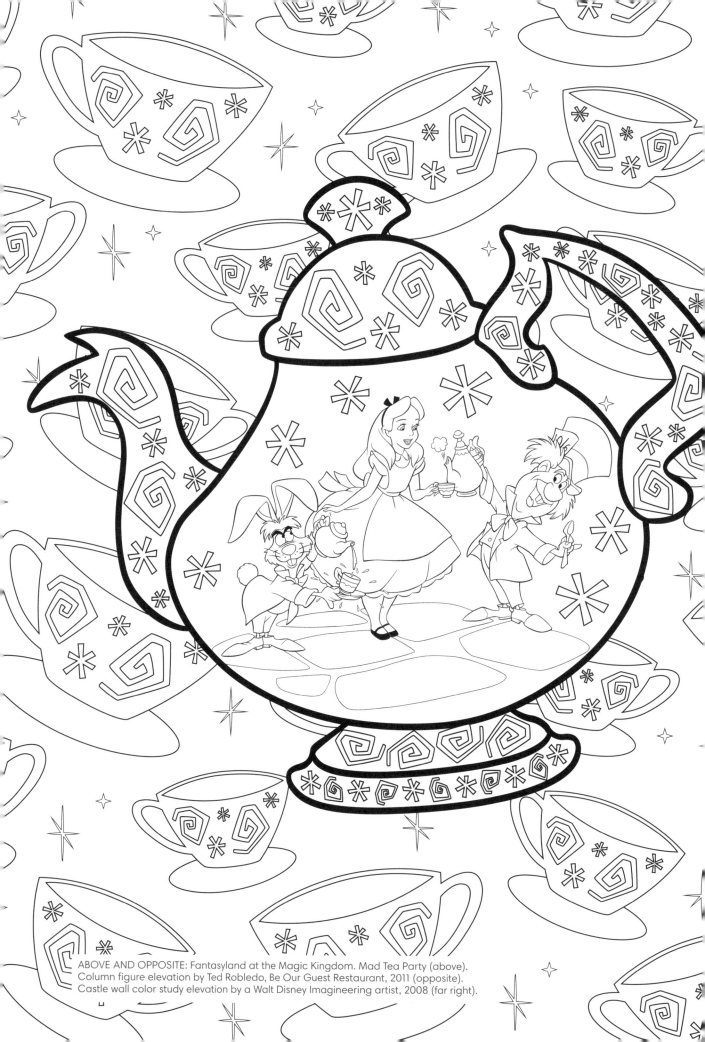

ABOVE AND OPPOSITE: Fantasyland at the Magic Kingdom. Mad Tea Party (above).
Column figure elevation by Ted Robledo, Be Our Guest Restaurant, 2011 (opposite).
Castle wall color study elevation by a Walt Disney Imagineering artist, 2008 (far right).

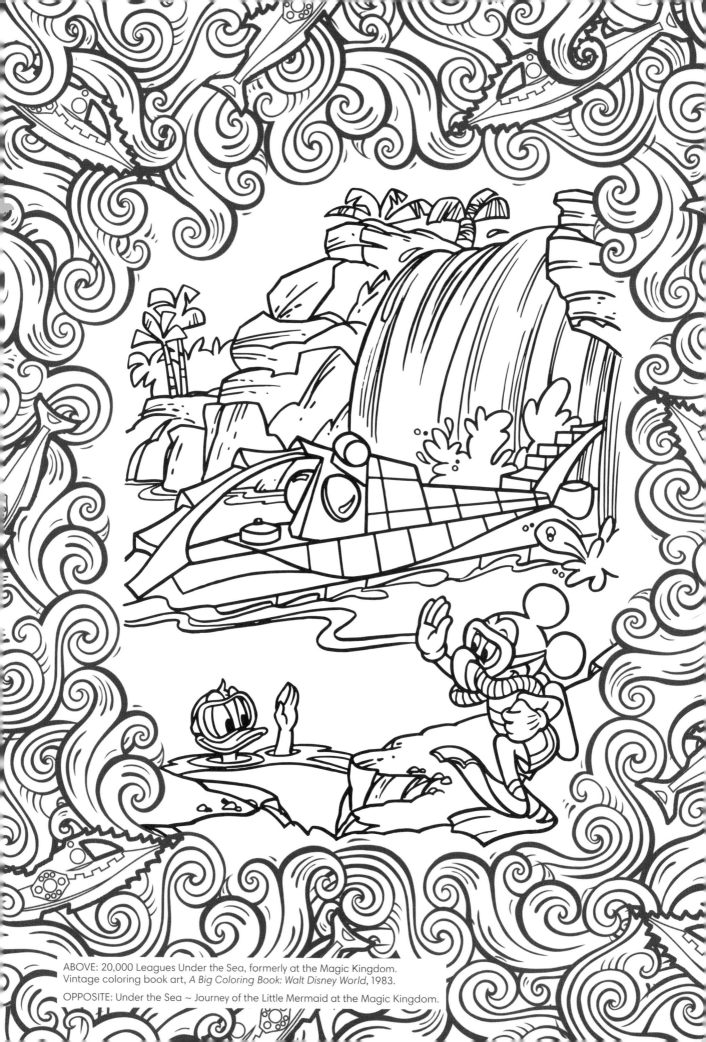

ABOVE: 20,000 Leagues Under the Sea, formerly at the Magic Kingdom. Vintage coloring book art, *A Big Coloring Book: Walt Disney World*, 1983.

OPPOSITE: Under the Sea ~ Journey of the Little Mermaid at the Magic Kingdom.

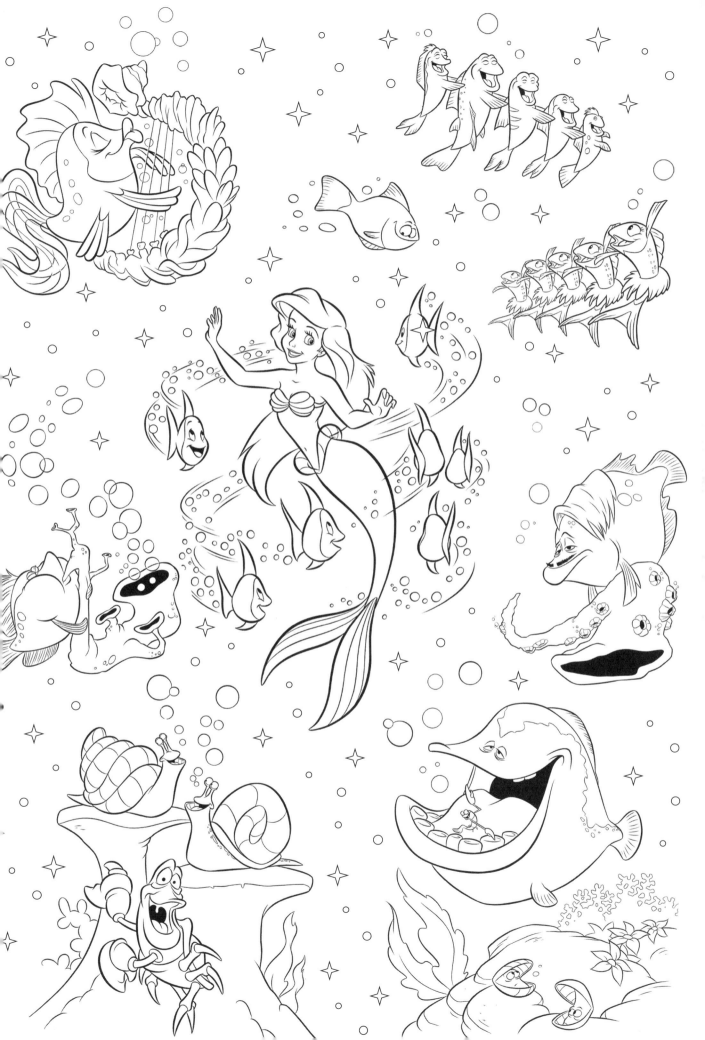

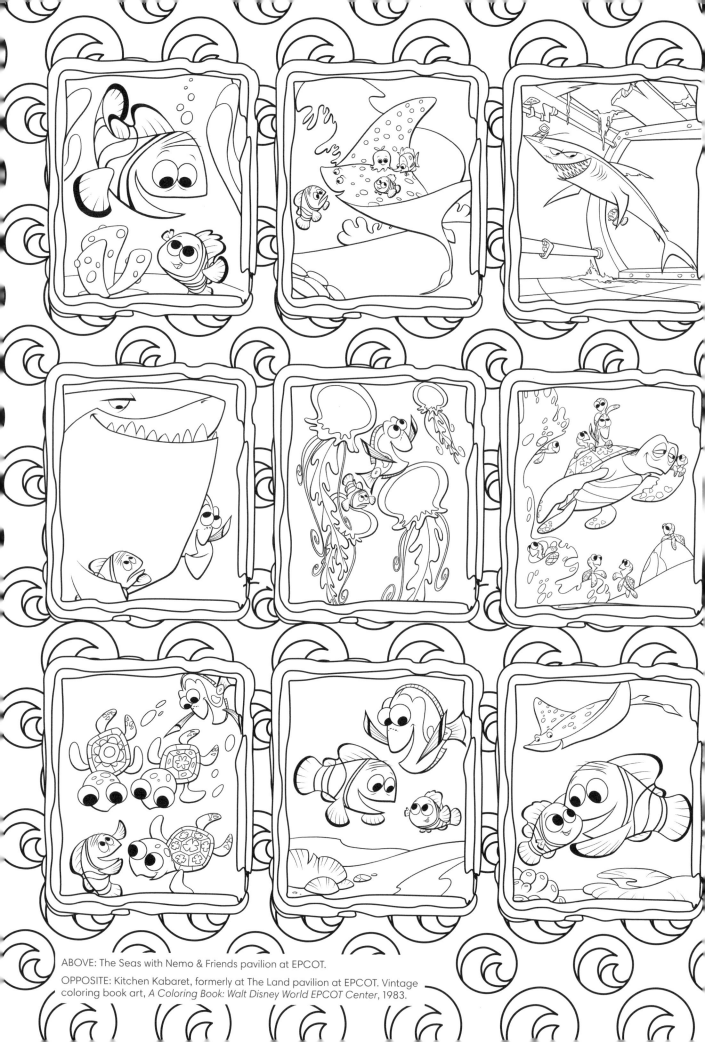

ABOVE: The Seas with Nemo & Friends pavilion at EPCOT.

OPPOSITE: Kitchen Kabaret, formerly at The Land pavilion at EPCOT. Vintage coloring book art, *A Coloring Book: Walt Disney World EPCOT Center*, 1983.

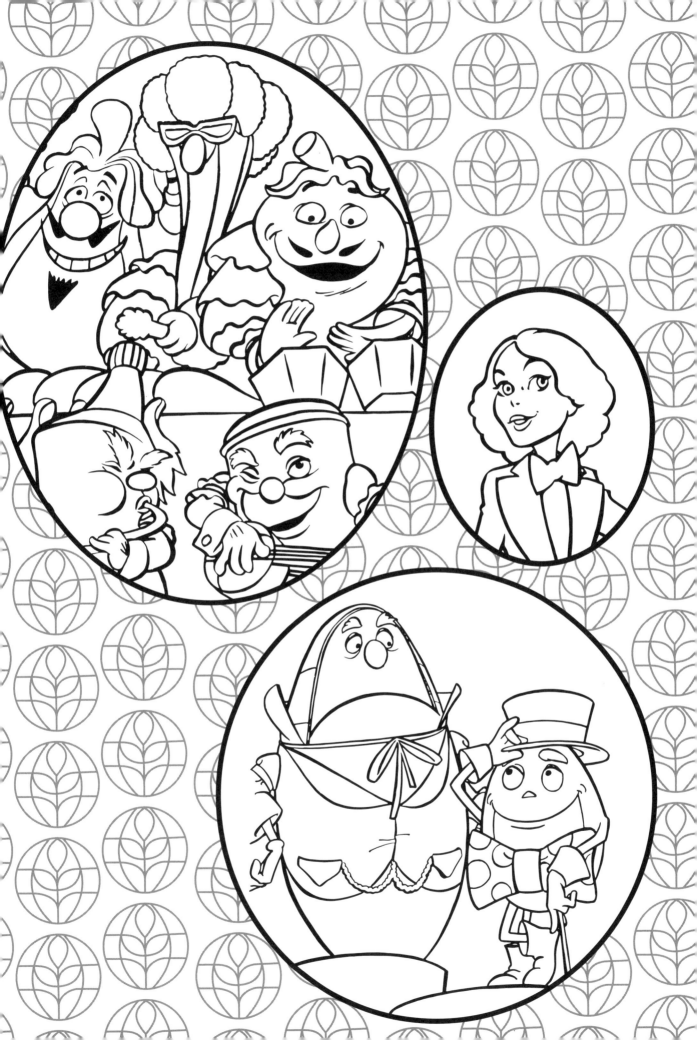

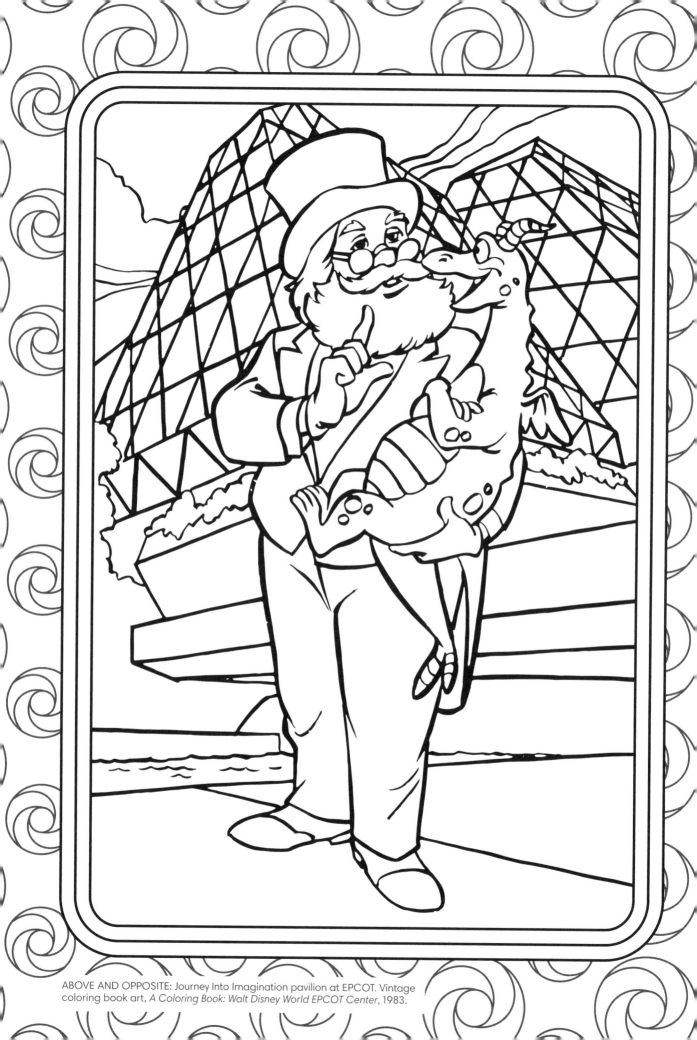

ABOVE AND OPPOSITE: Journey Into Imagination pavilion at EPCOT. Vintage coloring book art, *A Coloring Book: Walt Disney World EPCOT Center*, 1983.

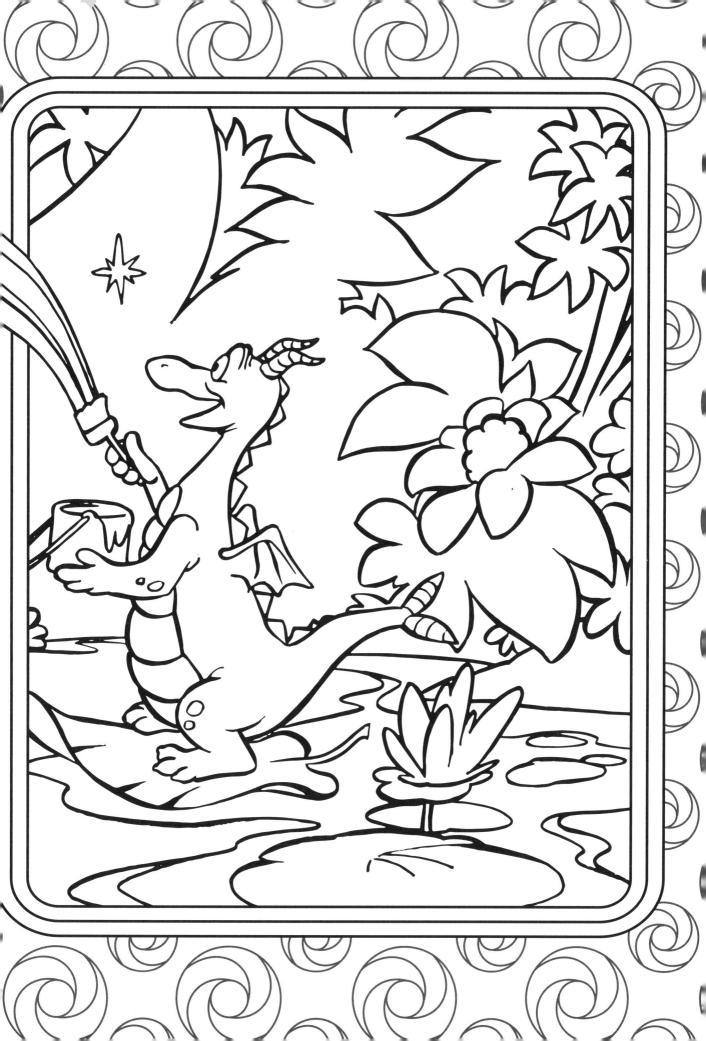

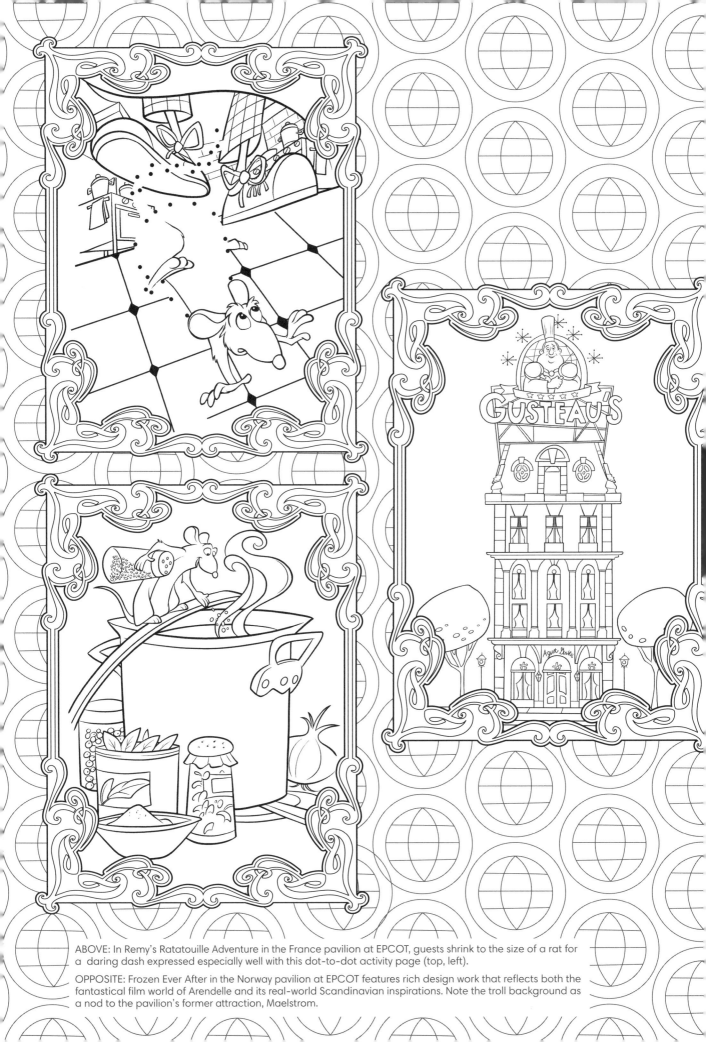

ABOVE: In Remy's Ratatouille Adventure in the France pavilion at EPCOT, guests shrink to the size of a rat for a daring dash expressed especially well with this dot-to-dot activity page (top, left).

OPPOSITE: Frozen Ever After in the Norway pavilion at EPCOT features rich design work that reflects both the fantastical film world of Arendelle and its real-world Scandinavian inspirations. Note the troll background as a nod to the pavilion's former attraction, Maelstrom.

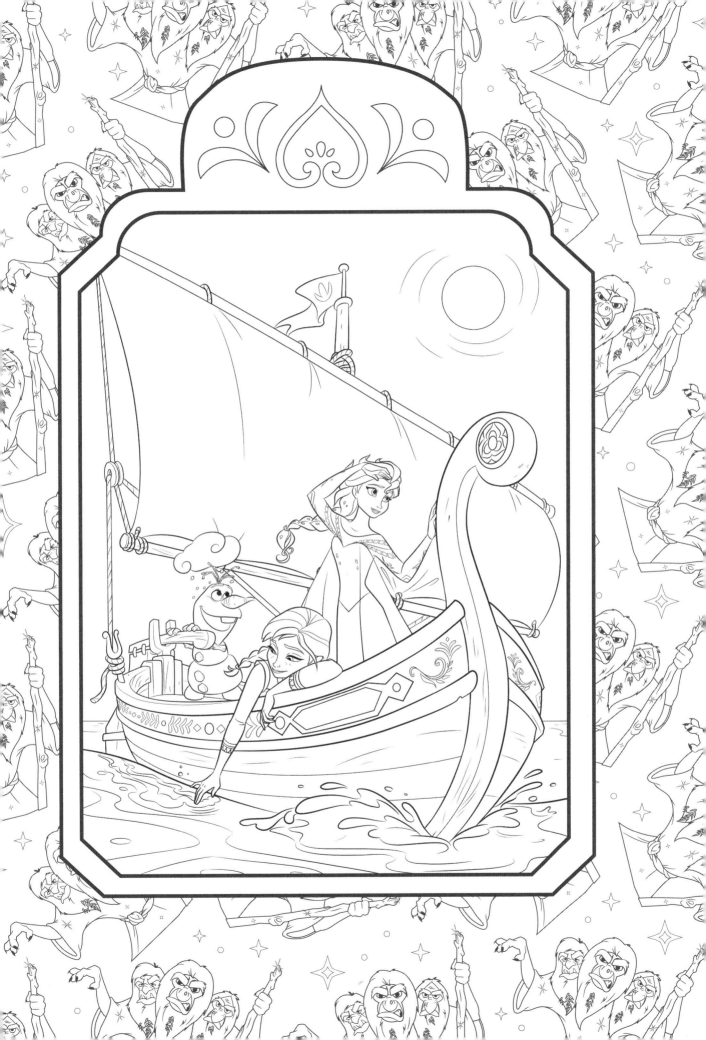

ABOVE AND OPPOSITE: Mickey & Minnie's Runaway Railway at Disney's Hollywood Studios. Neon attraction marquee, 2020 (opposite).

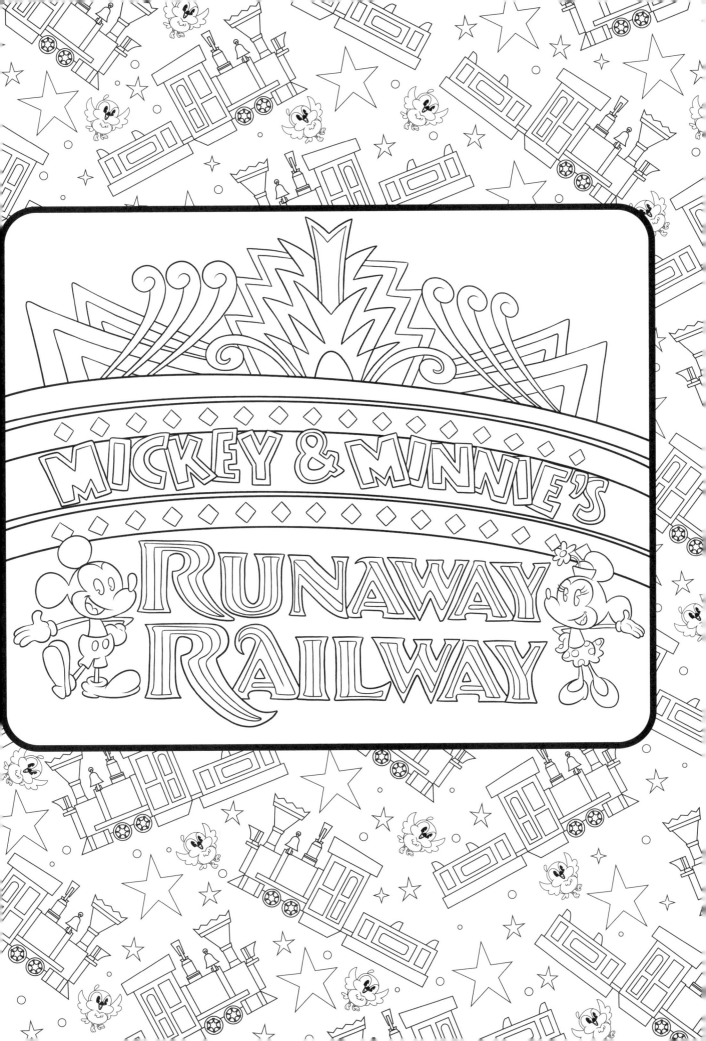

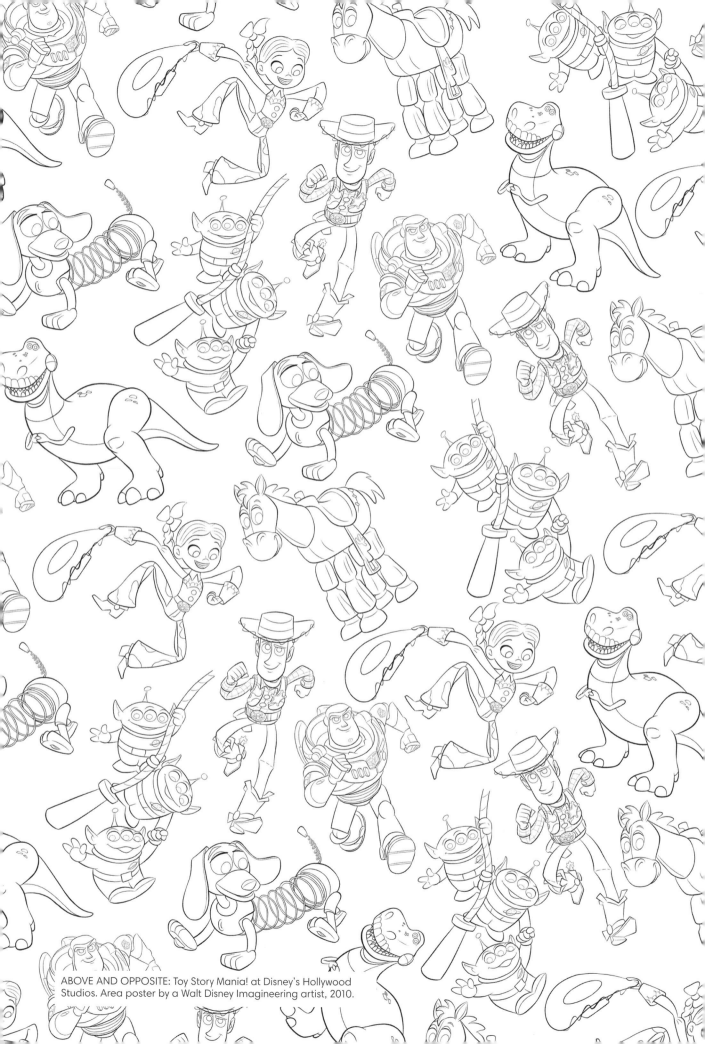

ABOVE AND OPPOSITE: Toy Story Mania! at Disney's Hollywood Studios. Area poster by a Walt Disney Imagineering artist, 2010.

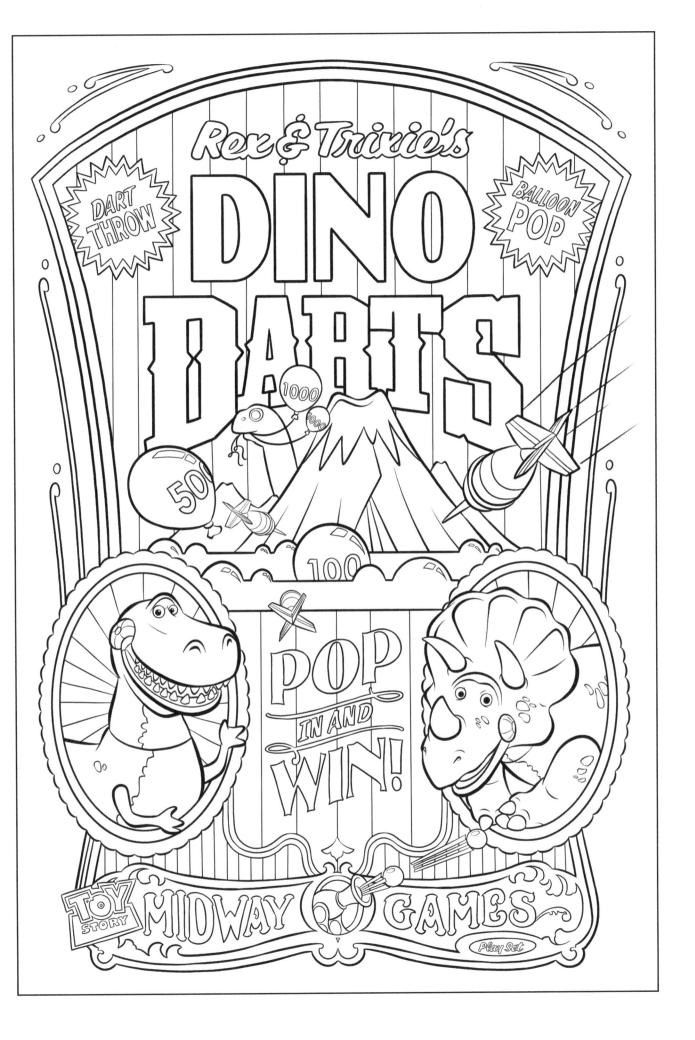

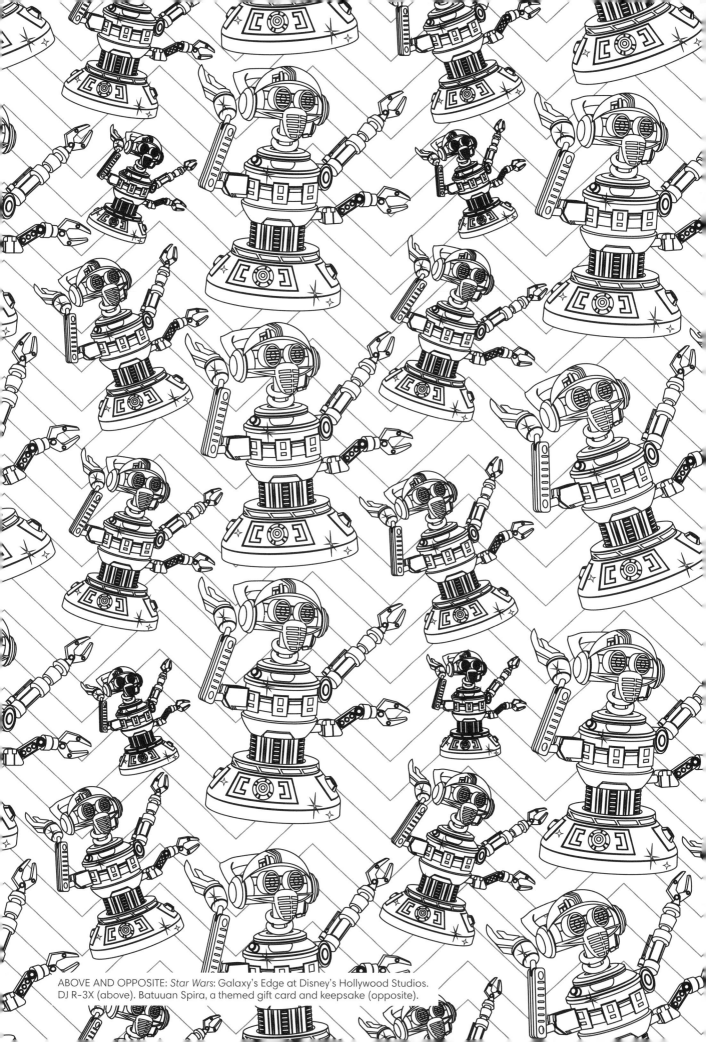

ABOVE AND OPPOSITE: *Star Wars*: Galaxy's Edge at Disney's Hollywood Studios.
DJ R-3X (above). Batuuan Spira, a themed gift card and keepsake (opposite).

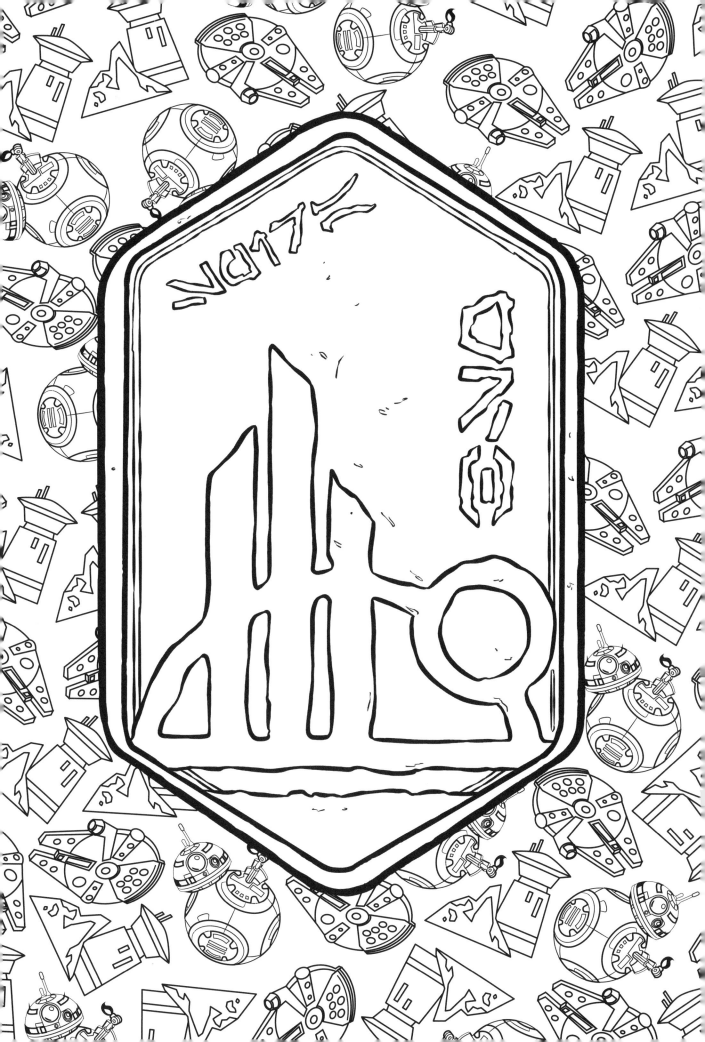

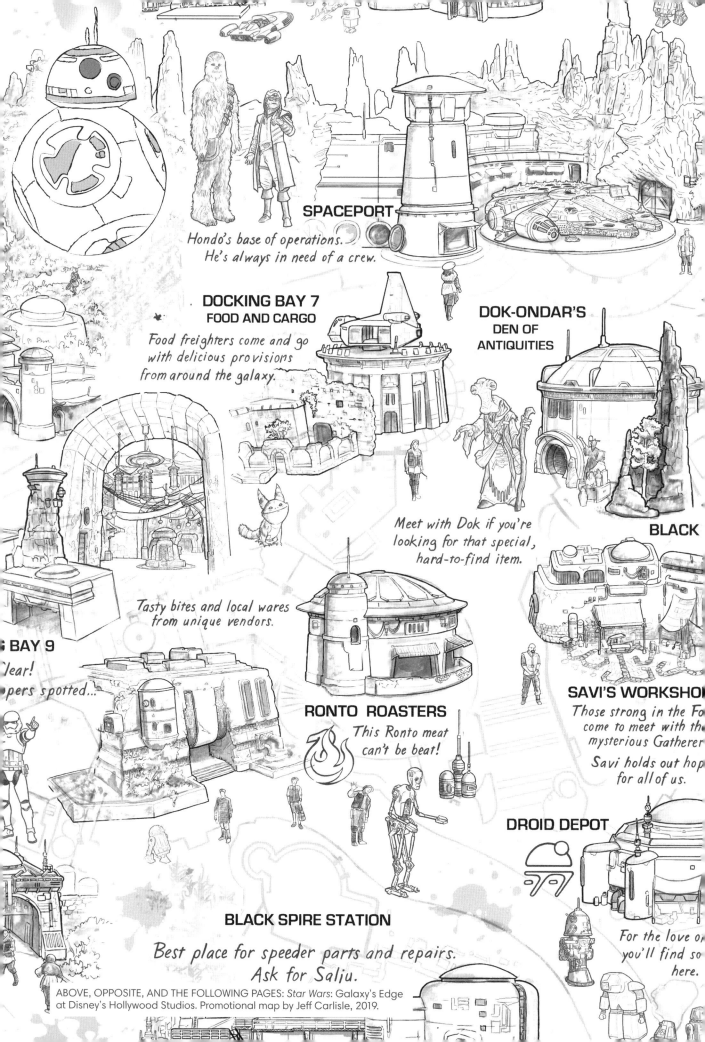

SPACEPORT

Hondo's base of operations.
He's always in need of a crew.

DOCKING BAY 7
FOOD AND CARGO

Food freighters come and go
with delicious provisions
from around the galaxy.

DOK-ONDAR'S
DEN OF
ANTIQUITIES

Meet with Dok if you're
looking for that special,
hard-to-find item.

BLACK

Tasty bites and local wares
from unique vendors.

BAY 9
lear!
pers spotted...

SAVI'S WORKSHO

Those strong in the Fo
come to meet with th
mysterious Gatherer

Savi holds out hop
for all of us.

RONTO ROASTERS

This Ronto meat
can't be beat!

DROID DEPOT

BLACK SPIRE STATION

Best place for speeder parts and repairs.
Ask for Salju.

For the love o
you'll find so
here.

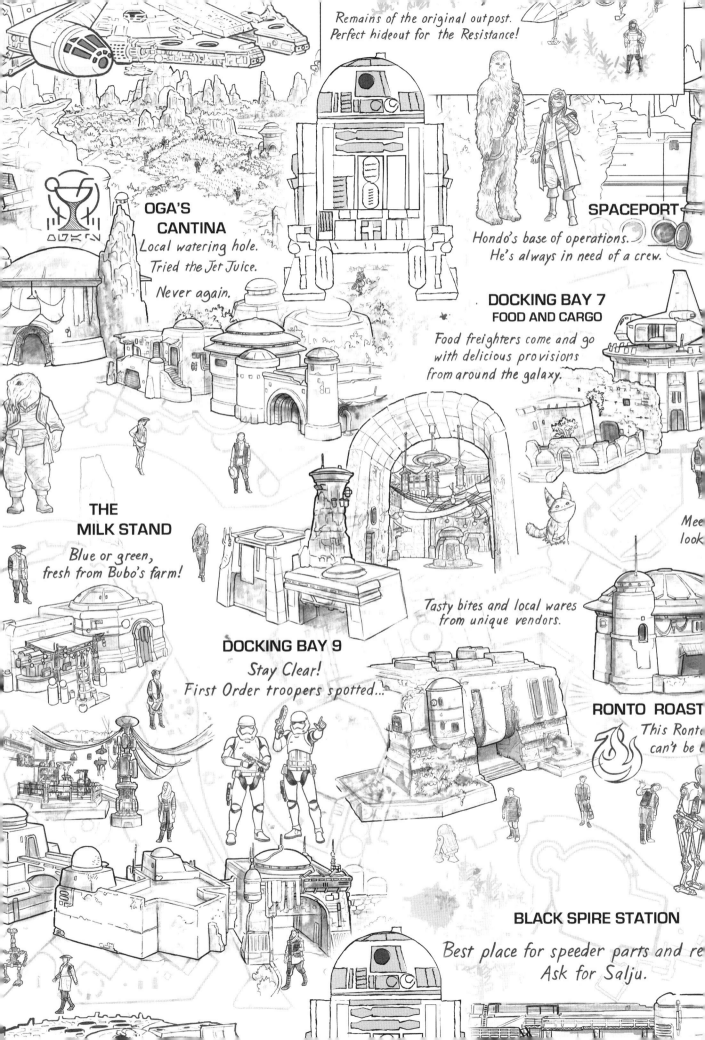

Remains of the original outpost.
Perfect hideout for the Resistance!

OGA'S CANTINA
Local watering hole.
Tried the Jet Juice.
Never again.

SPACEPORT
Hondo's base of operations.
He's always in need of a crew.

DOCKING BAY 7
FOOD AND CARGO
Food freighters come and go
with delicious provisions
from around the galaxy.

THE MILK STAND
Blue or green,
fresh from Bubo's farm!

Tasty bites and local wares
from unique vendors.

Mee
look

DOCKING BAY 9
Stay Clear!
First Order troopers spotted...

RONTO ROAST
This Ronto
can't be

BLACK SPIRE STATION
Best place for speeder parts and re
Ask for Salju.

BLACK SPIRE STATION

Best place for speeder parts and repairs.
Ask for Salju.

SPACEPORT

Hondo's base of operations.
He's always in need of a crew.

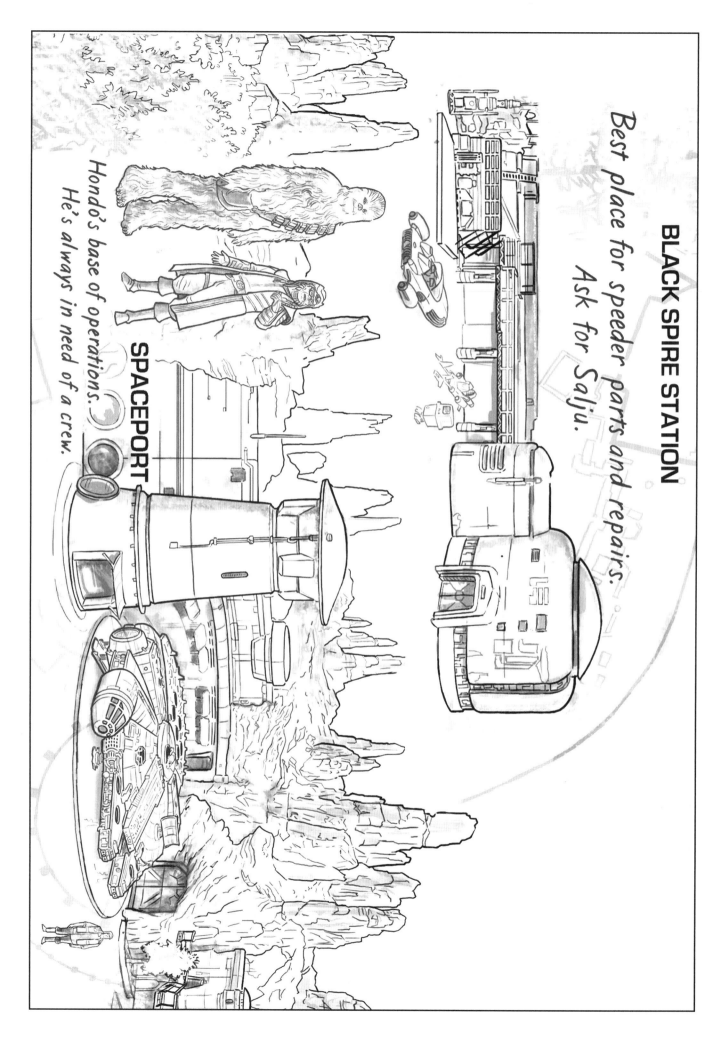

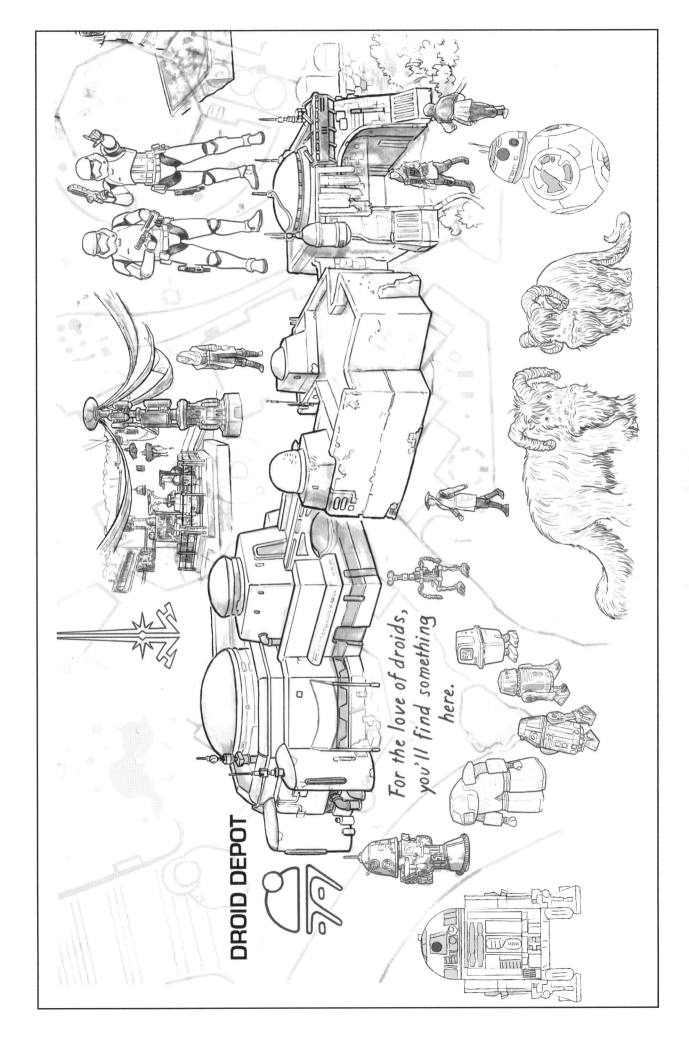

ABOVE AND OPPOSITE: Disney's Blizzard Beach Water Park. Marketing artwork by Jesse Clay, c. 1990s (opposite).

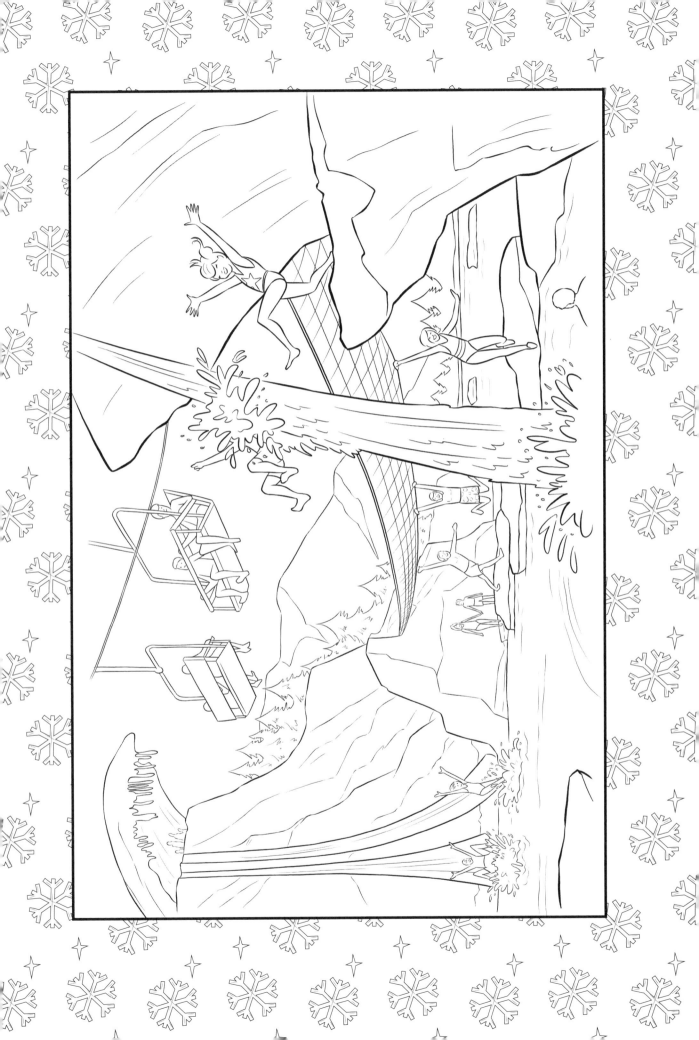

DISCOVERY
ADVENTURE AND EXPLORATION

We have always tried to be guided by the basic idea that, in the discovery of knowledge, there is great entertainment—as, conversely, in all good entertainment, there is always some grain of wisdom, humanity, or enlightenment to be gained.

—Walt Disney[D.1]

THERE IS PERHAPS NO BETTER WORD TO ENCAPSULATE the experience of visiting Walt Disney World than *opportunity*. What the resort consistently accomplishes across its vast acreage is offering up thrilling, sometimes chilling, and always inspiring adventures to the millions of guests who visit each year. Creating such a multitude of inspirational offerings is no small task and is an operation steeped in countless hours of research in the name of worldly authenticity. Carmen Smith, Executive Creative Development and Inclusive Strategies, Walt Disney Imagineering, emphasizes, "As Imagineers, it is our responsibility to ensure experiences we create and stories we share reflect the voices and perspectives of the world around us."[D.2]

For those who wish to venture deep into the wilds of the resort's Floridian expanse, cutting their own path to new knowledge, the siren call to discover the unknown abounds, too. From treetop perches and deep-sea exploration, to international ports of call and the farthest reaches of space, an adventurous soul will find whole new worlds to embrace at each of the four theme parks, two water parks, and numerous resort hotels while on site. Adventure is out there at Walt Disney World . . . all we have to do is seek it out!

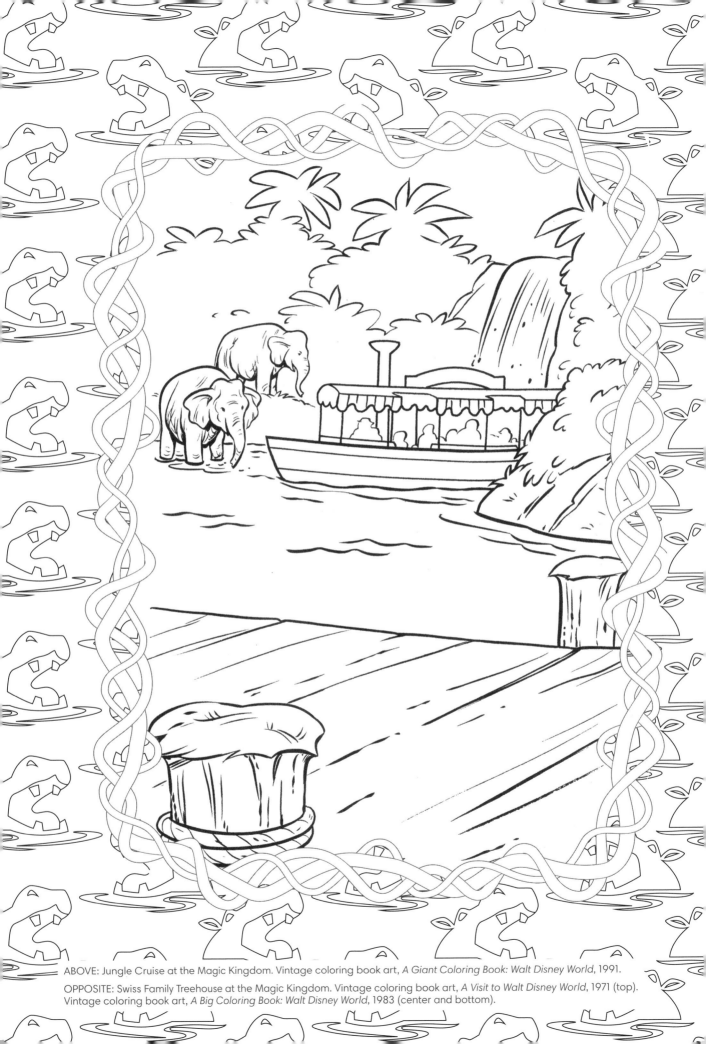

ABOVE: Jungle Cruise at the Magic Kingdom. Vintage coloring book art, *A Giant Coloring Book: Walt Disney World*, 1991.

OPPOSITE: Swiss Family Treehouse at the Magic Kingdom. Vintage coloring book art, *A Visit to Walt Disney World*, 1971 (top). Vintage coloring book art, *A Big Coloring Book: Walt Disney World*, 1983 (center and bottom).

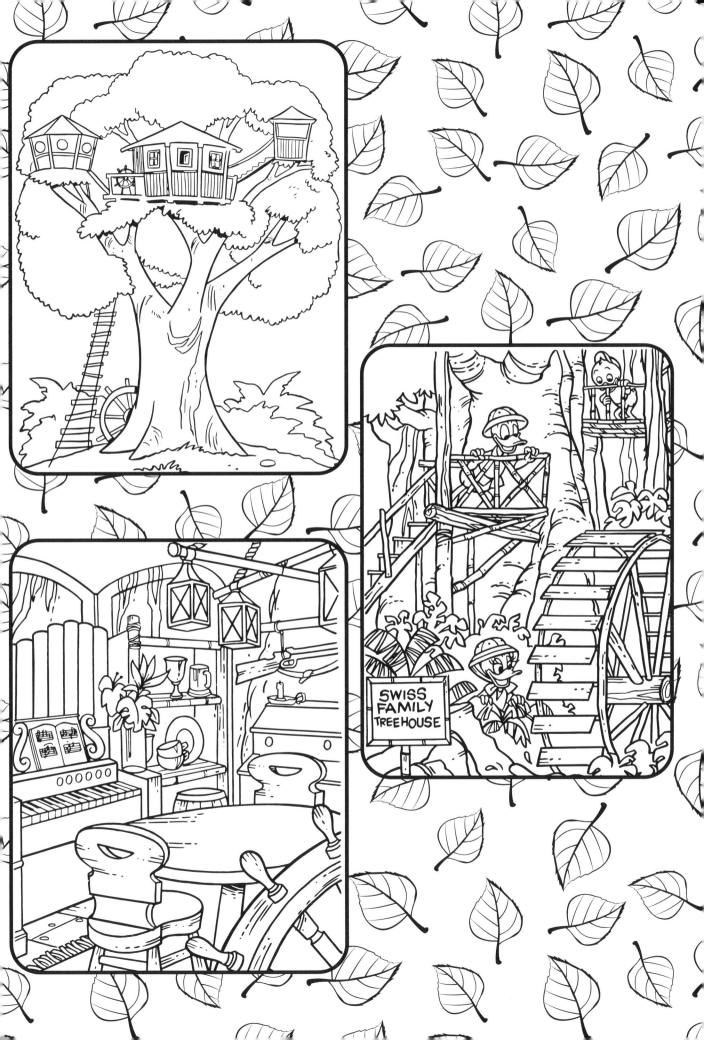

ABOVE: Walt Disney's Enchanted Tiki Room, the Orange Bird, The Magic Carpets of Aladdin, and Pirates of the Caribbean in Adventureland at the Magic Kingdom.

OPPOSITE: Attraction poster art by Paul Hartley, Tropical Serenade, 1971.

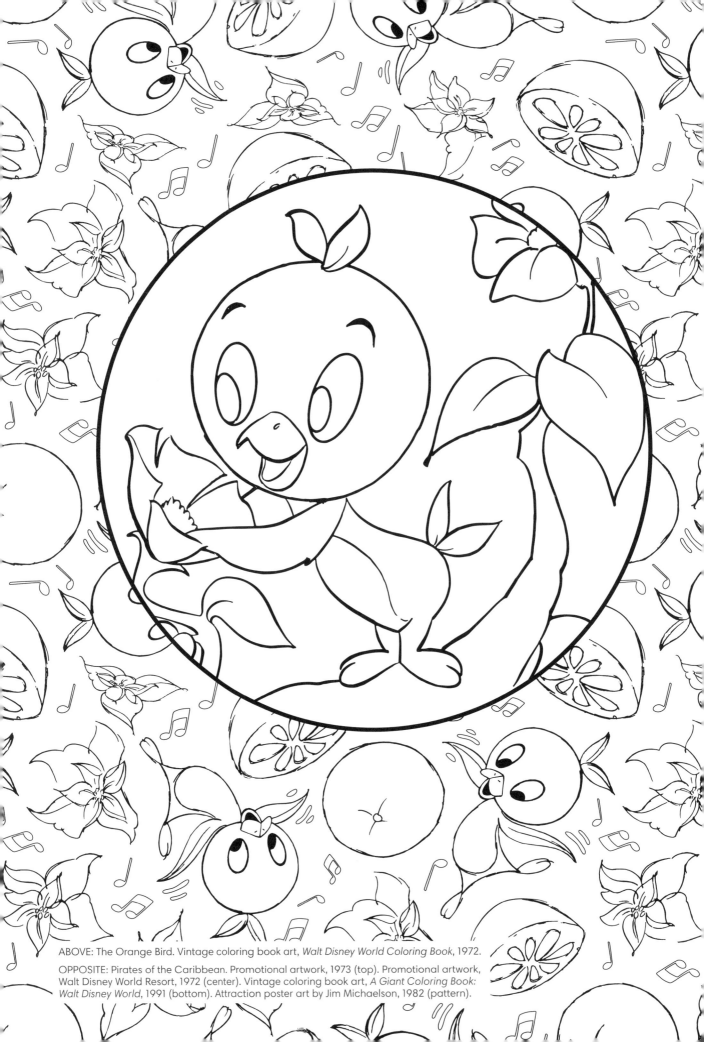

ABOVE: The Orange Bird. Vintage coloring book art, *Walt Disney World Coloring Book*, 1972.

OPPOSITE: Pirates of the Caribbean. Promotional artwork, 1973 (top). Promotional artwork, Walt Disney World Resort, 1972 (center). Vintage coloring book art, *A Giant Coloring Book: Walt Disney World*, 1991 (bottom). Attraction poster art by Jim Michaelson, 1982 (pattern).

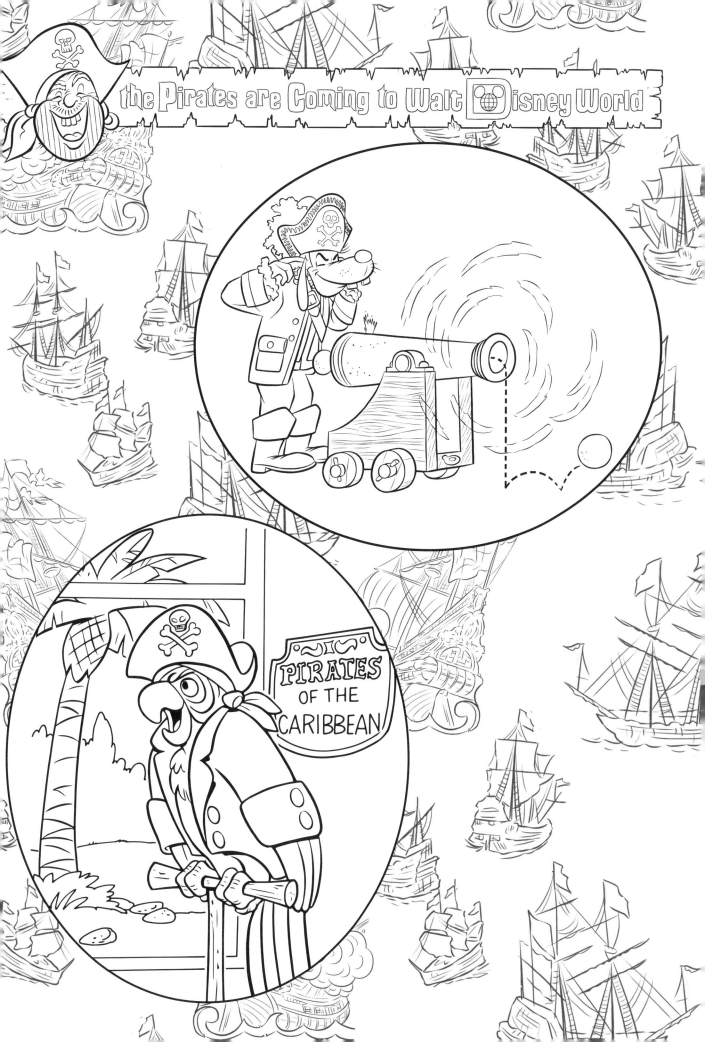

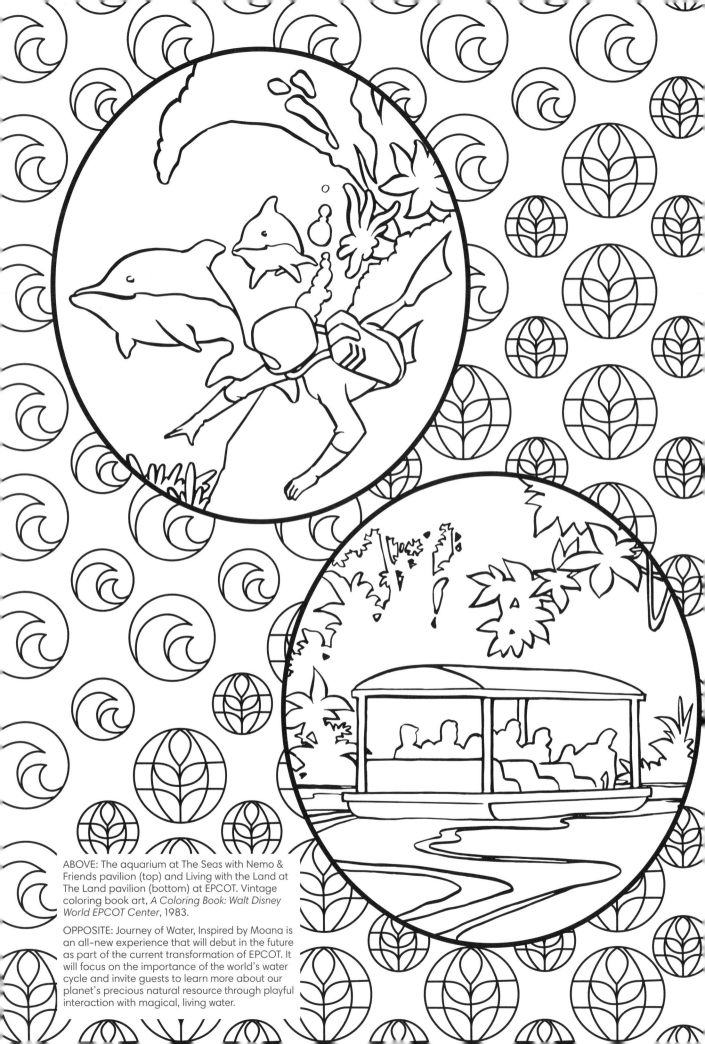

ABOVE: The aquarium at The Seas with Nemo & Friends pavilion (top) and Living with the Land at The Land pavilion (bottom) at EPCOT. Vintage coloring book art, *A Coloring Book: Walt Disney World EPCOT Center*, 1983.

OPPOSITE: Journey of Water, Inspired by Moana is an all-new experience that will debut in the future as part of the current transformation of EPCOT. It will focus on the importance of the world's water cycle and invite guests to learn more about our planet's precious natural resource through playful interaction with magical, living water.

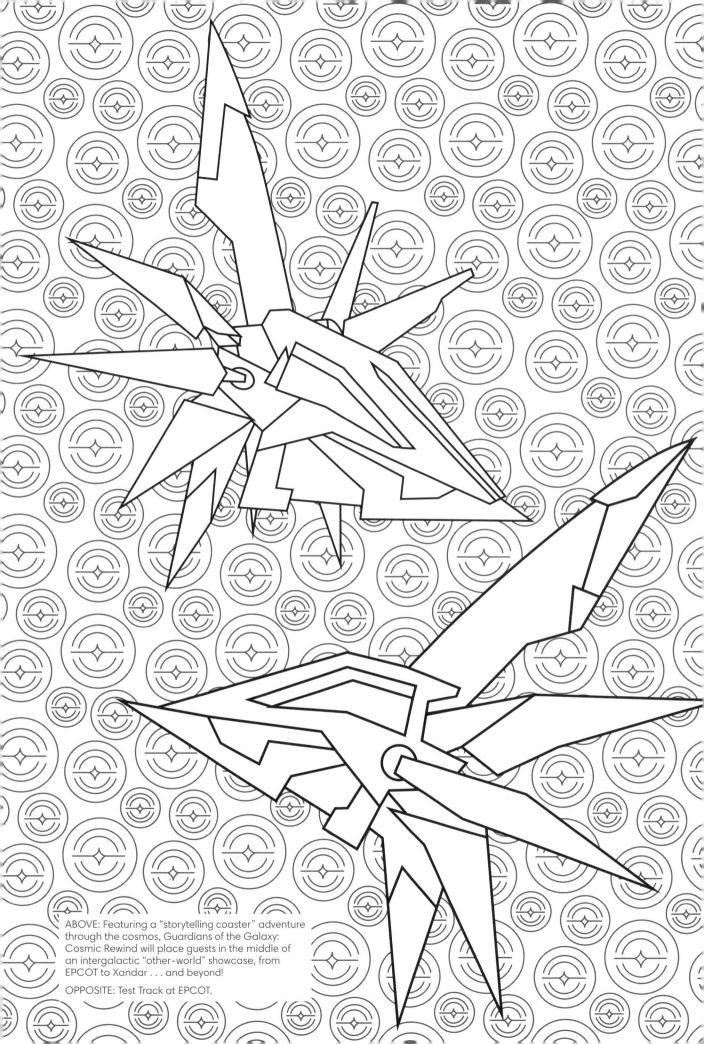

ABOVE: Featuring a "storytelling coaster" adventure through the cosmos, Guardians of the Galaxy: Cosmic Rewind will place guests in the middle of an intergalactic "other-world" showcase, from EPCOT to Xandar . . . and beyond!

OPPOSITE: Test Track at EPCOT.

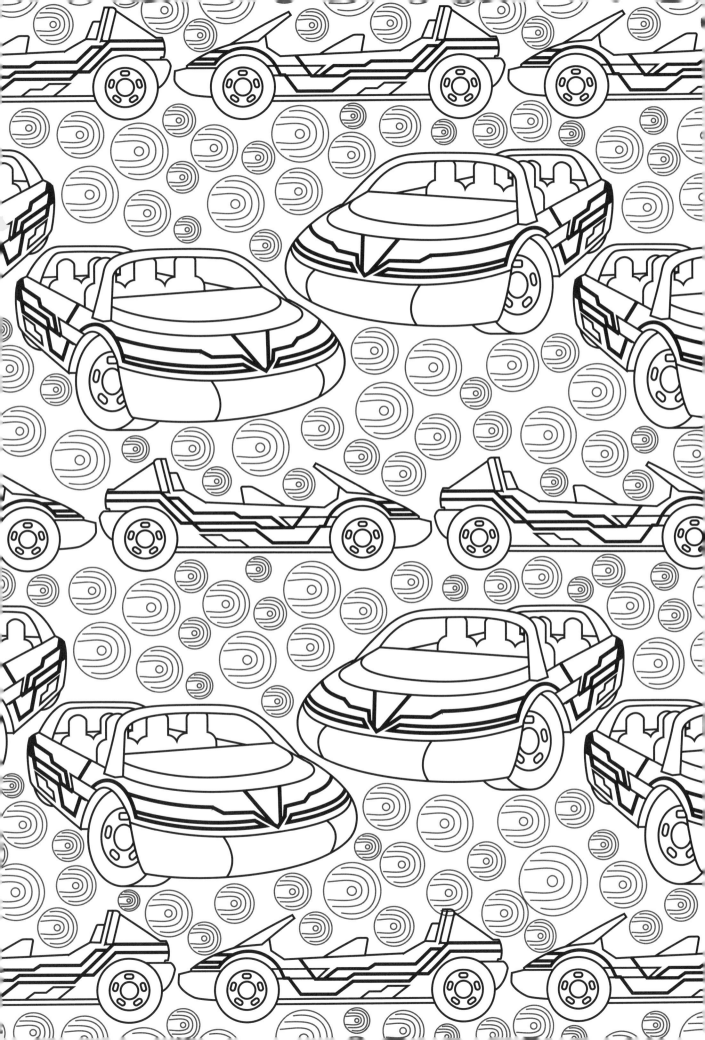

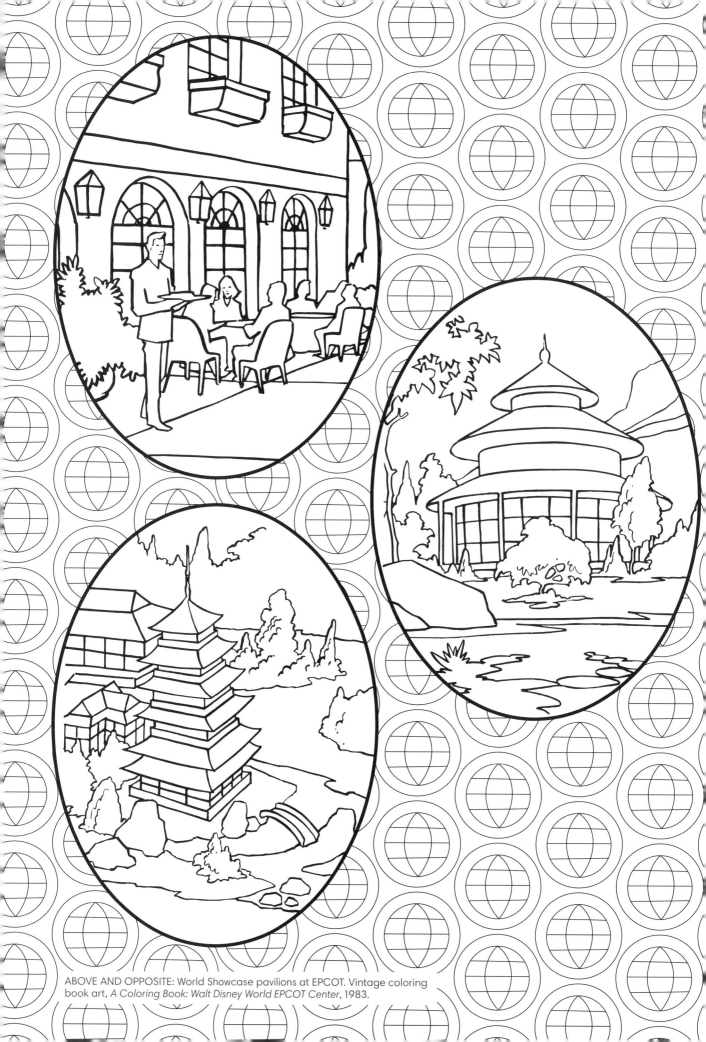

ABOVE AND OPPOSITE: World Showcase pavilions at EPCOT. Vintage coloring book art, *A Coloring Book: Walt Disney World EPCOT Center*, 1983.

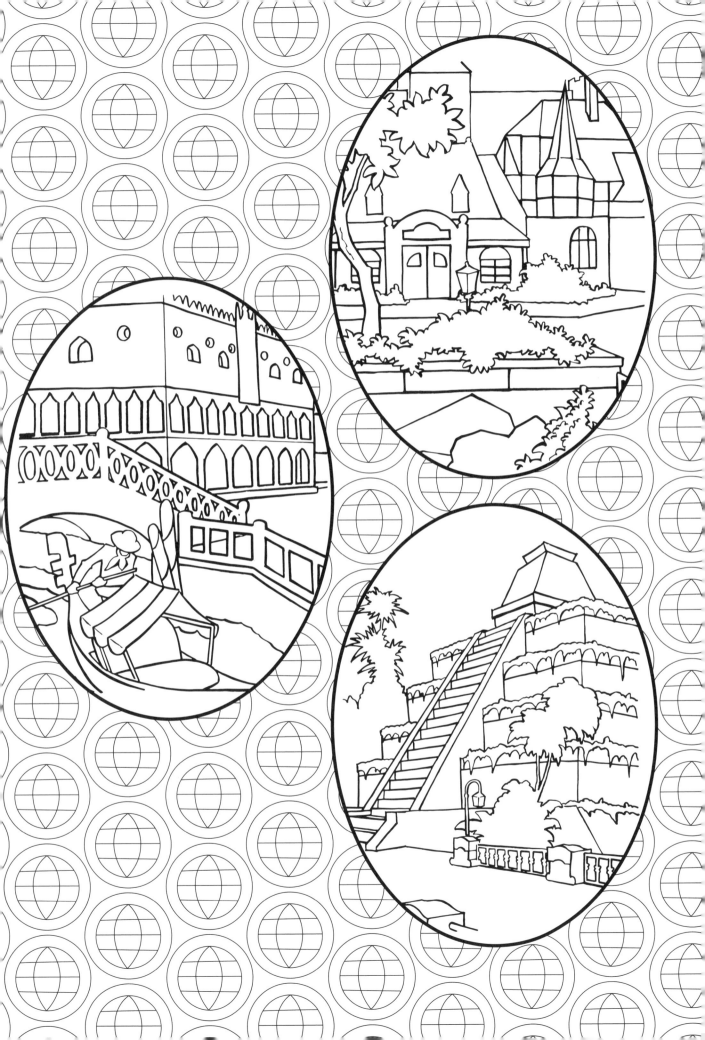

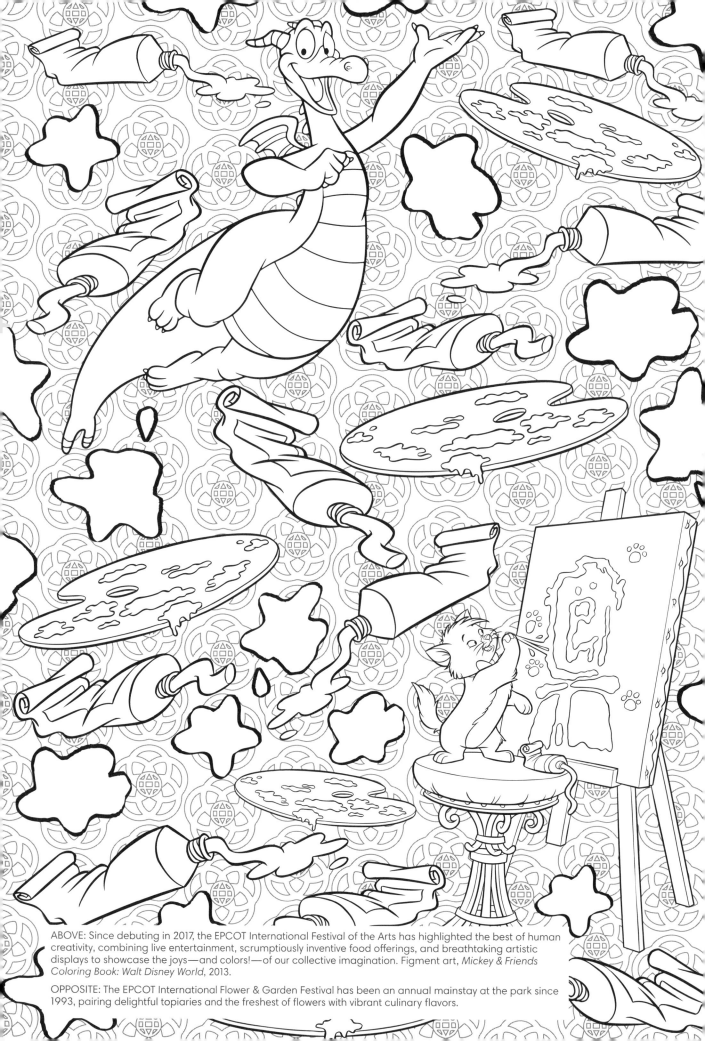

ABOVE: Since debuting in 2017, the EPCOT International Festival of the Arts has highlighted the best of human creativity, combining live entertainment, scrumptiously inventive food offerings, and breathtaking artistic displays to showcase the joys—and colors!—of our collective imagination. Figment art, *Mickey & Friends Coloring Book: Walt Disney World*, 2013.

OPPOSITE: The EPCOT International Flower & Garden Festival has been an annual mainstay at the park since 1993, pairing delightful topiaries and the freshest of flowers with vibrant culinary flavors.

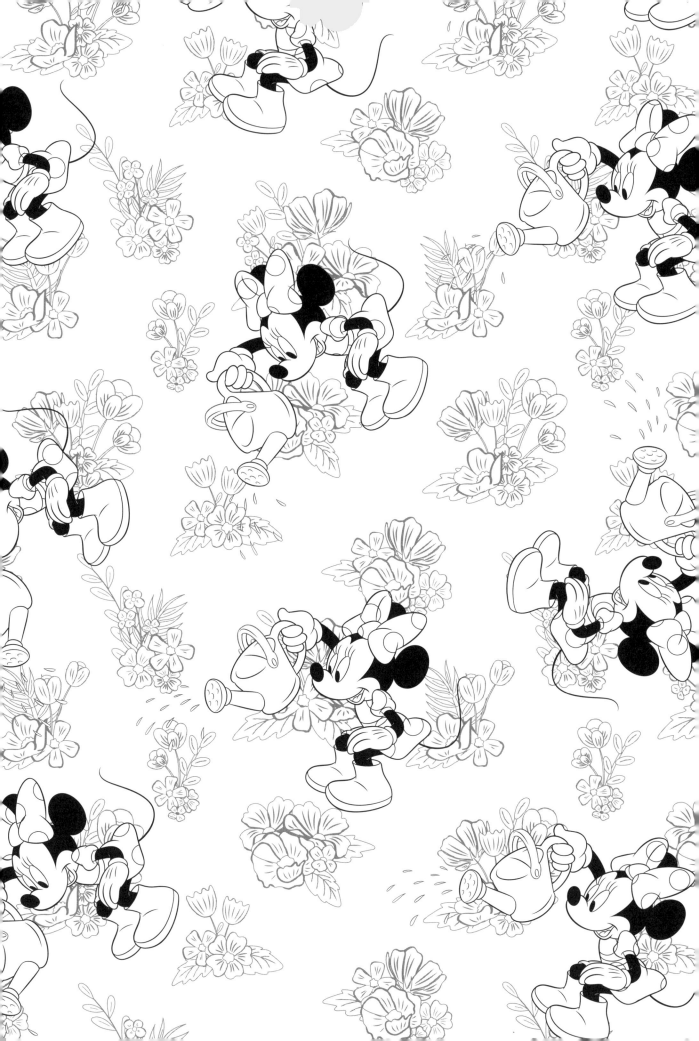

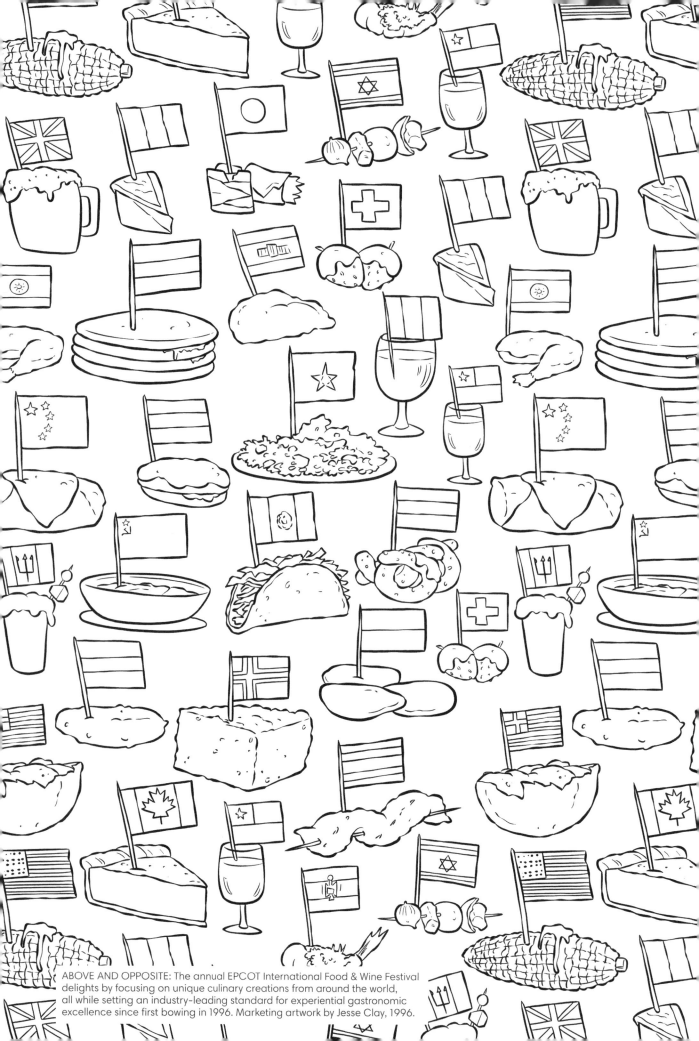

ABOVE AND OPPOSITE: The annual EPCOT International Food & Wine Festival delights by focusing on unique culinary creations from around the world, all while setting an industry-leading standard for experiential gastronomic excellence since first bowing in 1996. Marketing artwork by Jesse Clay, 1996.

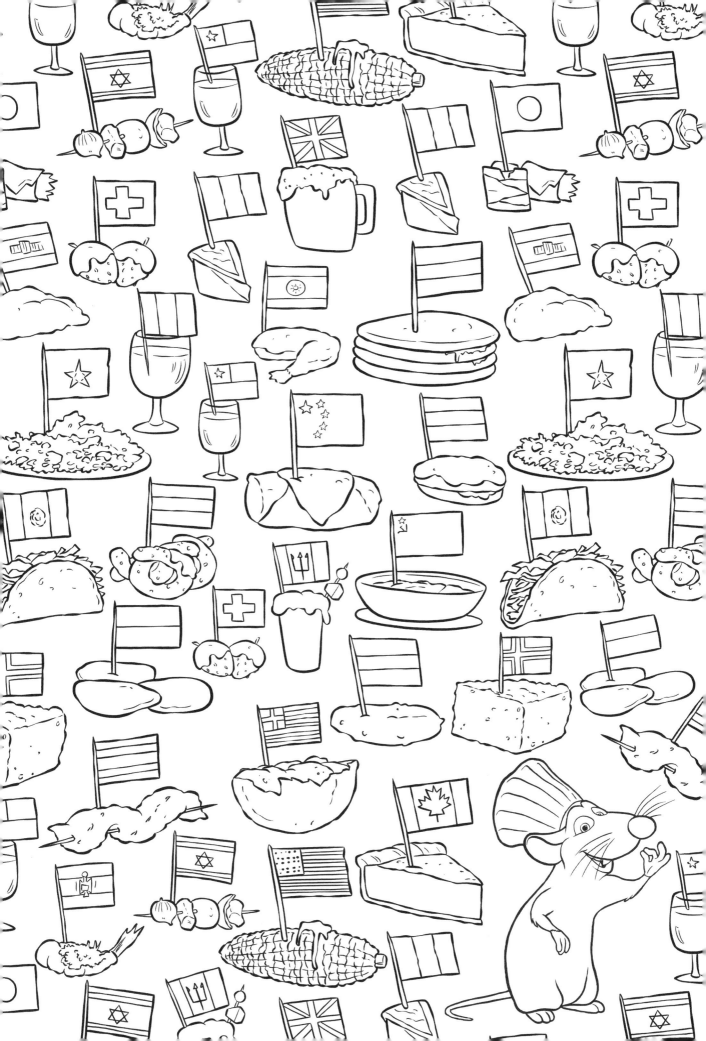

OPPOSITE: DINOSAUR at Disney's Animal Kingdom Theme Park.

ABOVE AND OPPOSITE: Kilimanjaro Safaris at Disney's Animal Kingdom Theme Park.

ABOVE AND OPPOSITE: Kilimanjaro Safaris at Disney's Animal Kingdom Theme Park.

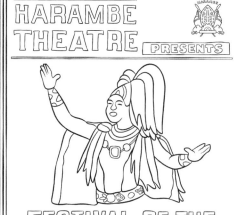
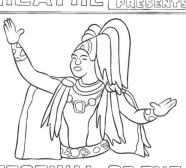

ABOVE AND OPPOSITE: Festival of the Lion King area poster at Disney's Animal Kingdom Theme Park.

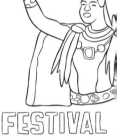
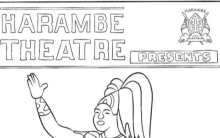

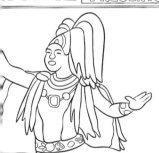

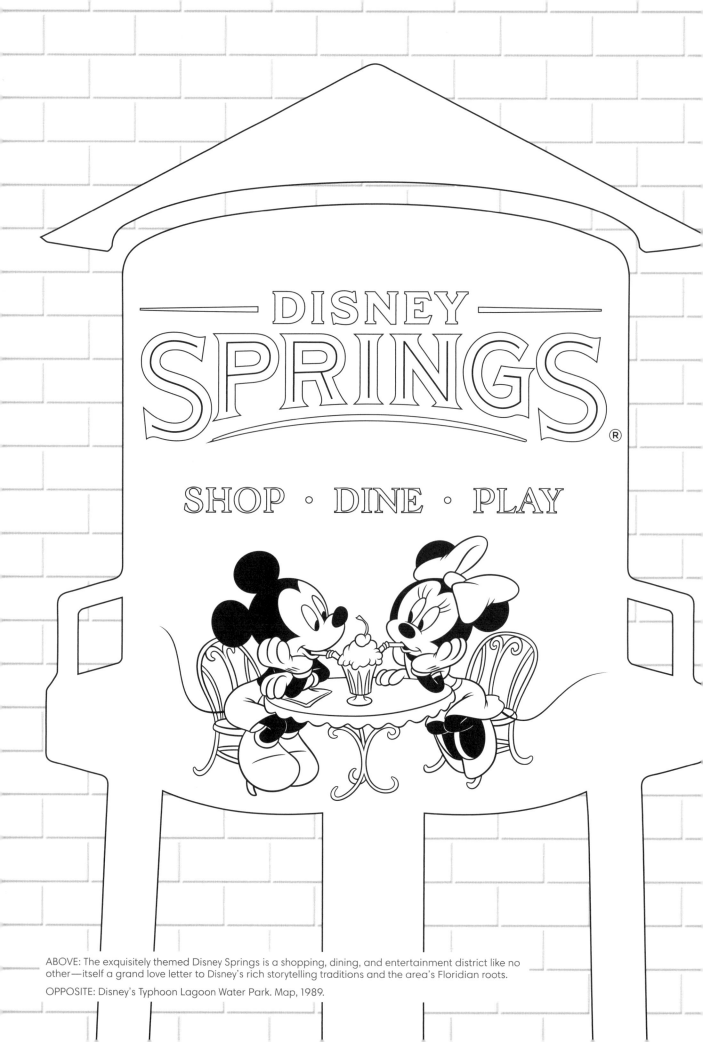

ABOVE: The exquisitely themed Disney Springs is a shopping, dining, and entertainment district like no other—itself a grand love letter to Disney's rich storytelling traditions and the area's Floridian roots.

OPPOSITE: Disney's Typhoon Lagoon Water Park. Map, 1989.

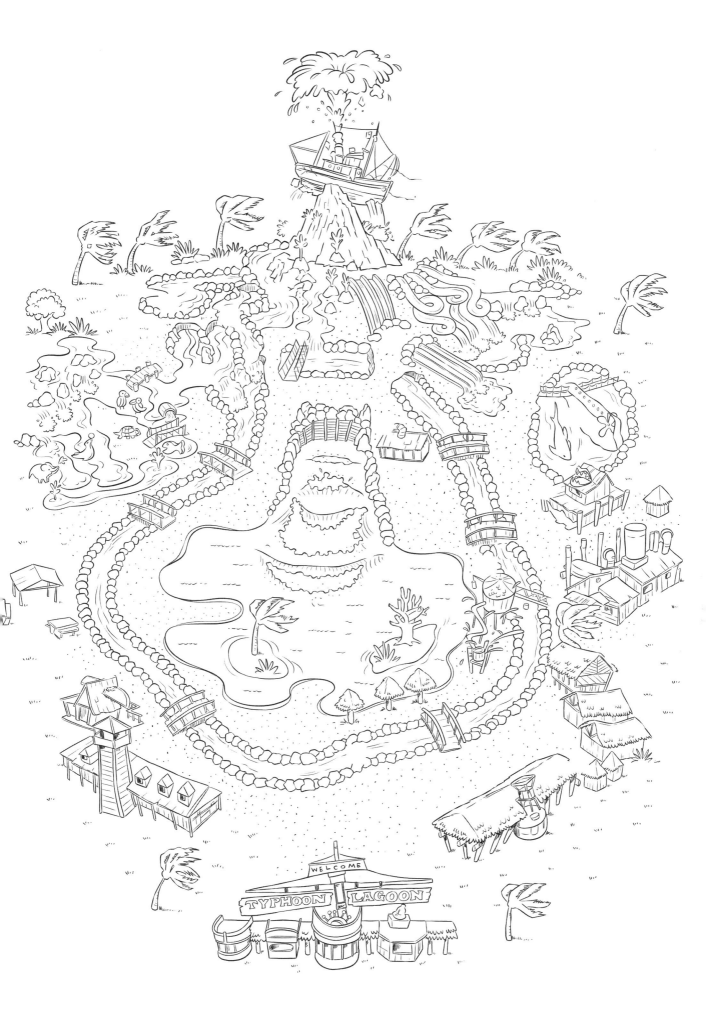

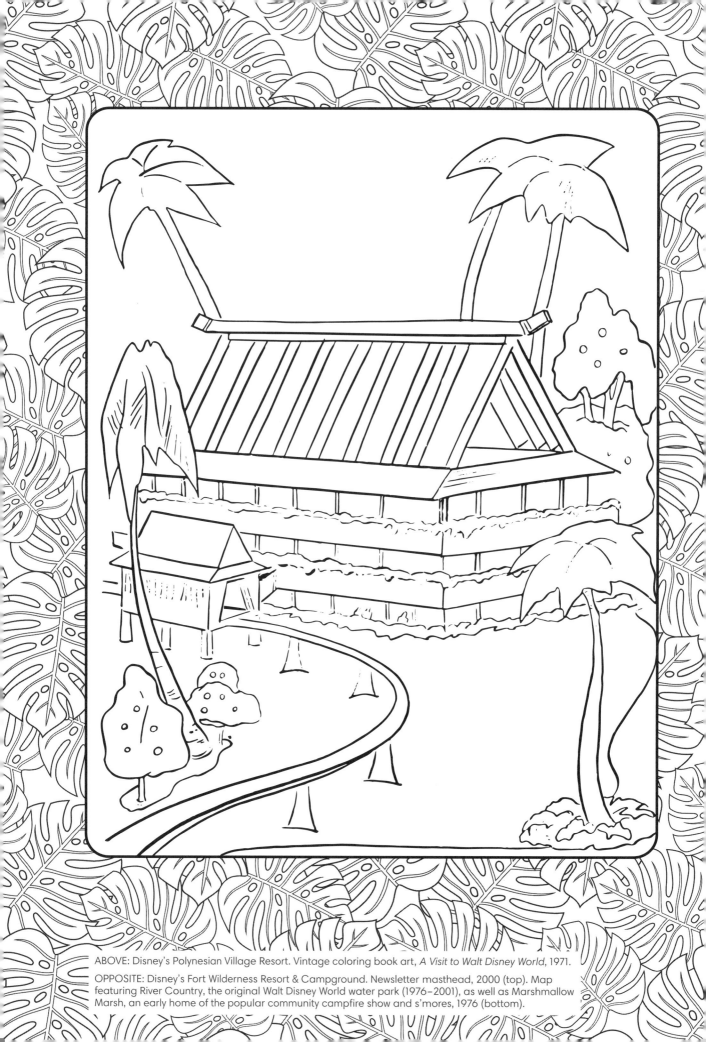

ABOVE: Disney's Polynesian Village Resort. Vintage coloring book art, *A Visit to Walt Disney World*, 1971.

OPPOSITE: Disney's Fort Wilderness Resort & Campground. Newsletter masthead, 2000 (top). Map featuring River Country, the original Walt Disney World water park (1976–2001), as well as Marshmallow Marsh, an early home of the popular community campfire show and s'mores, 1976 (bottom).

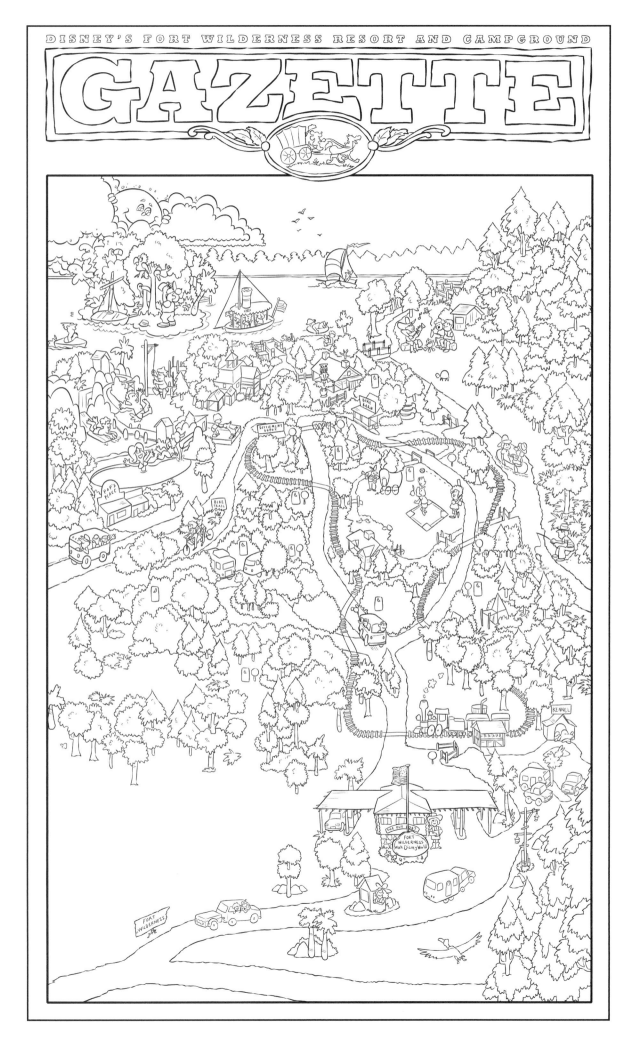

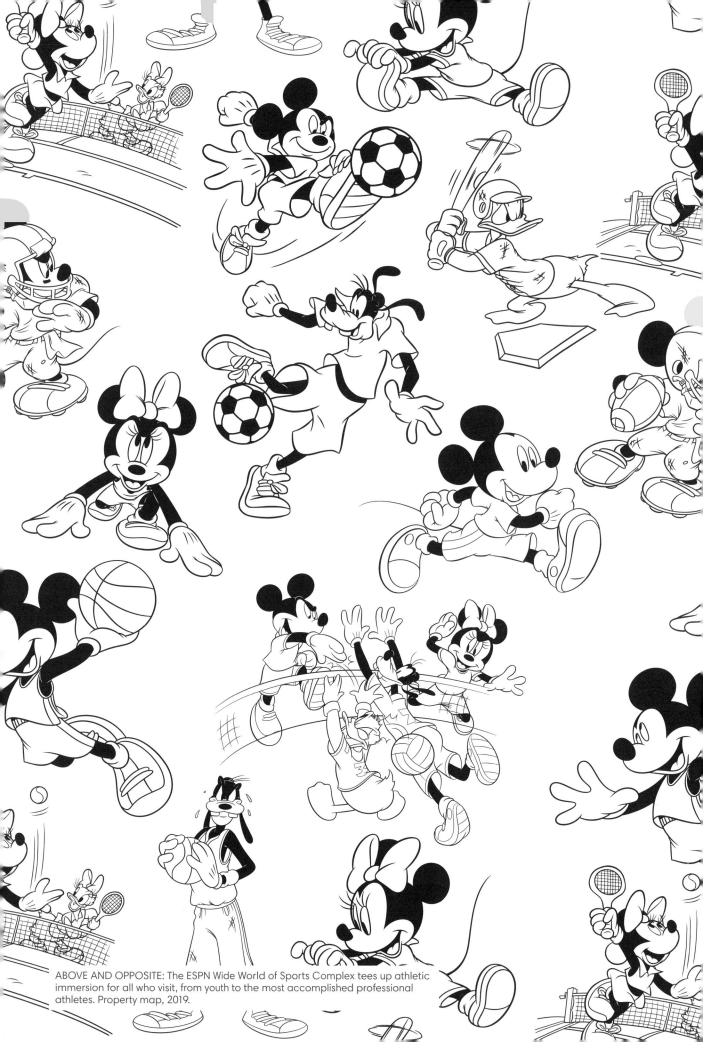

ABOVE AND OPPOSITE: The ESPN Wide World of Sports Complex tees up athletic immersion for all who visit, from youth to the most accomplished professional athletes. Property map, 2019.

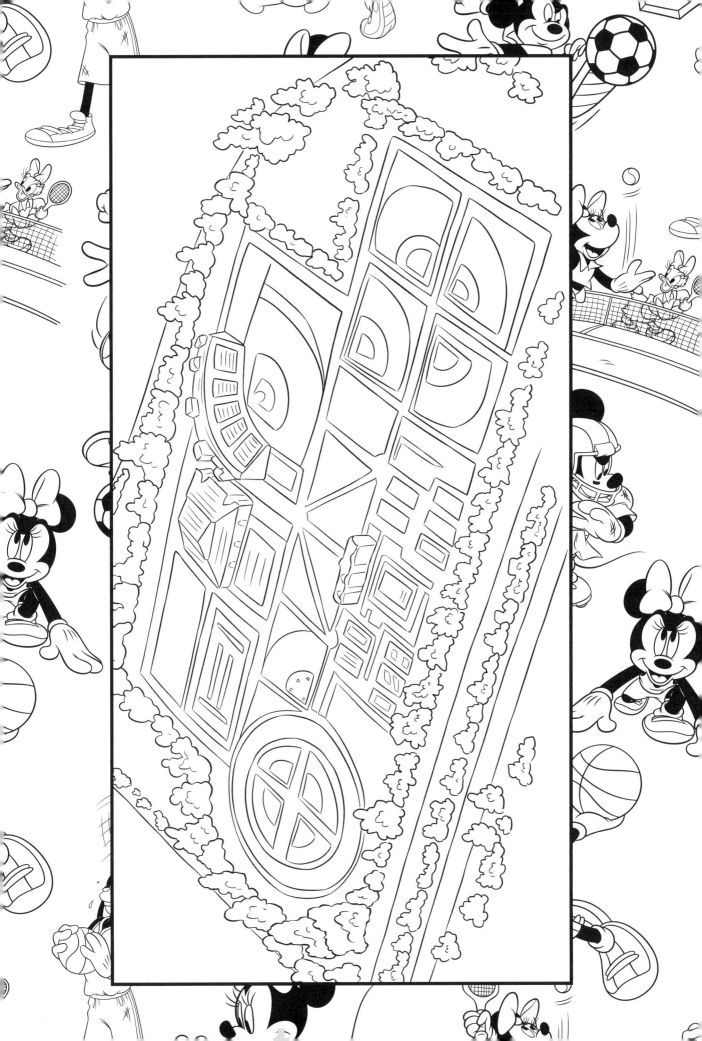

TOMORROW
A STEP INTO THE FUTURE

Tomorrow offers new frontiers in science, adventure, and ideals . . . and the hope for a peaceful and unified world.

—Walt Disney[T.1]

THE MAGIC OF POSSIBILITY IS WHAT ENTICES ALL DREAMERS, and the prospects of what tomorrow *can* bring help frame up some of the richest and most imaginative experiences that exist at Walt Disney World. Whether we're taking a chance to float, fly, scurry, race, taste, sing, play, or grow at EPCOT, or taking in the newest and most advanced attractions found at the Magic Kingdom or Disney's Hollywood Studios, it's nearly impossible *not* to be inspired by what has been created at the resort over the last five decades. A commitment to constant technological breakthroughs and regular reinvention also inspires and informs these new experiences—something that has been a part of the site's unique identity since its very beginnings.

Operating at the crux of entertainment and innovation, Walt Disney World has always sought to highlight the best in humanity, including our shared goals of making the world a better place for all who inhabit this fragile spaceship known as Earth. Taking a cue from the central message of Walt's own Carousel of Progress attraction, the resort reinforces the inspired thought that there really is a beautiful tomorrow just a dream away. Fortunately, we can always see many cutting-edge dreams—and even some creative real-world logistical solutions!—on display at Walt Disney World, perfectly at work.

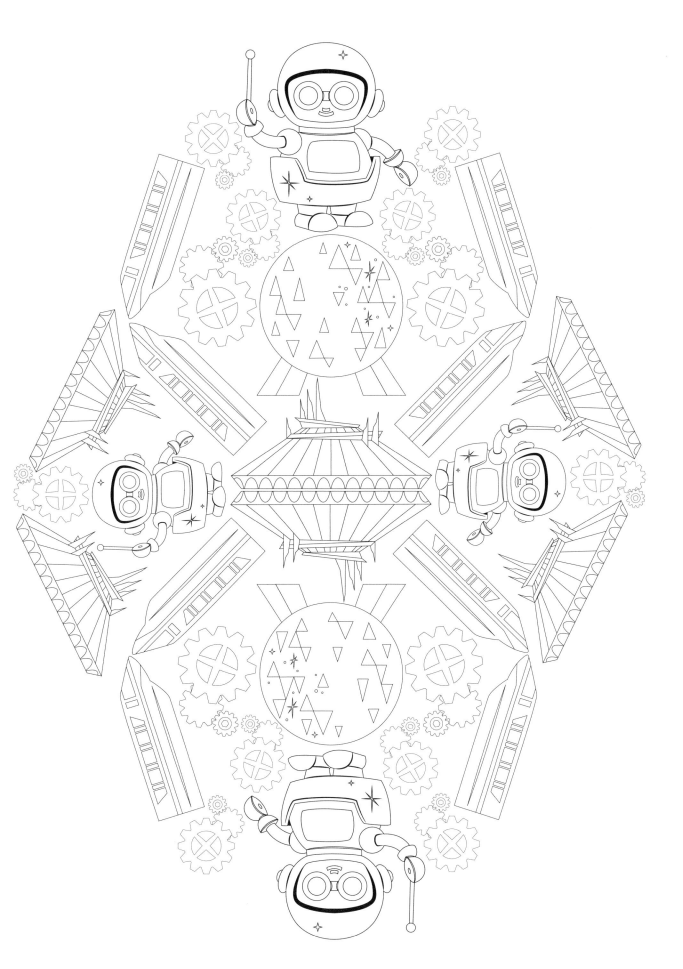

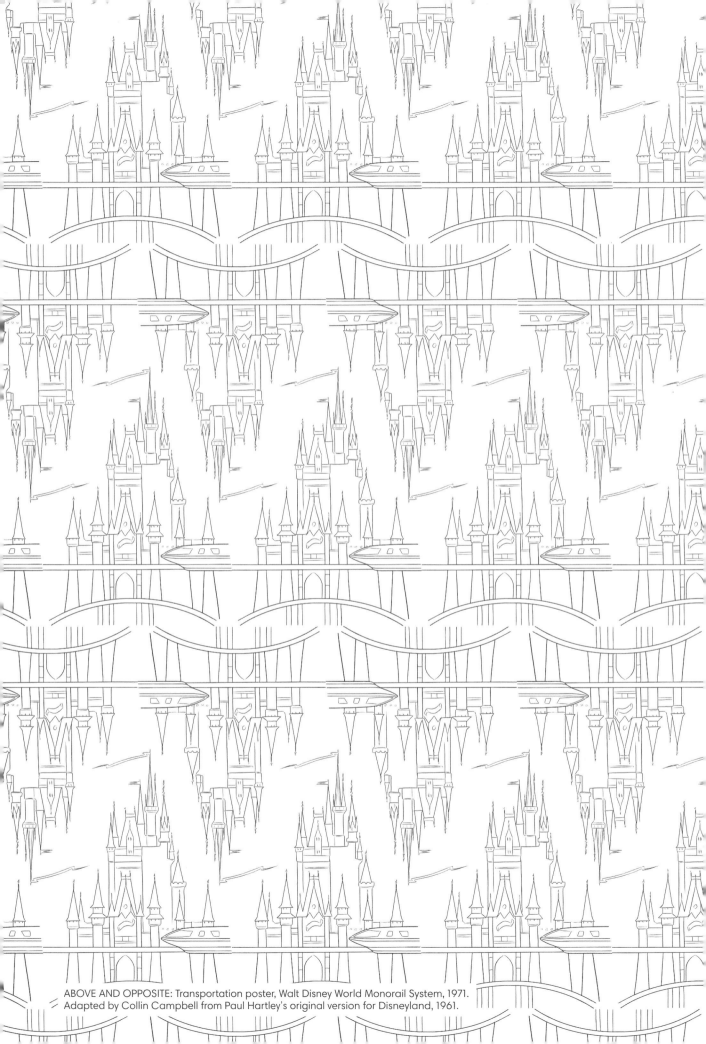

ABOVE AND OPPOSITE: Transportation poster, Walt Disney World Monorail System, 1971.
Adapted by Collin Campbell from Paul Hartley's original version for Disneyland, 1961.

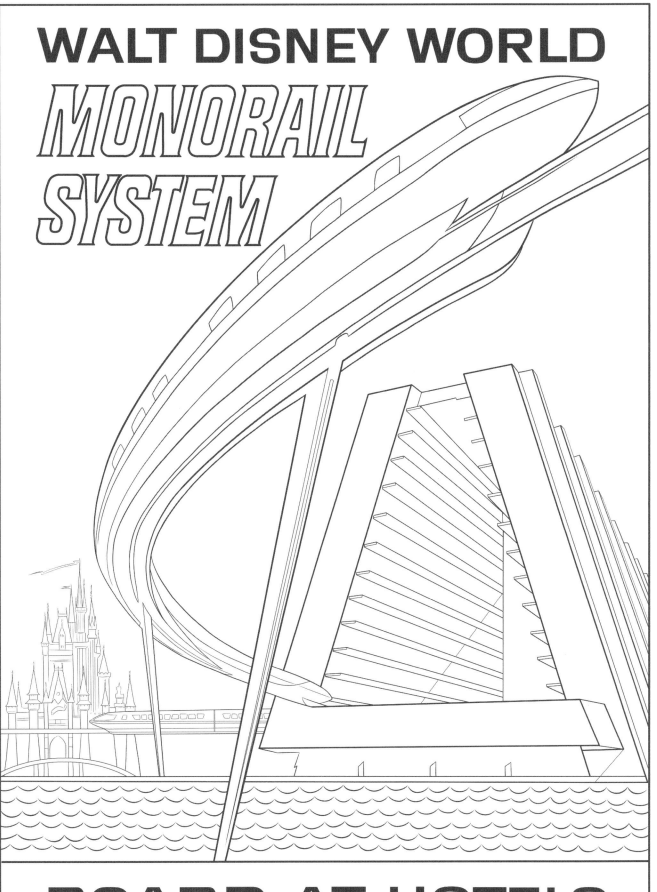

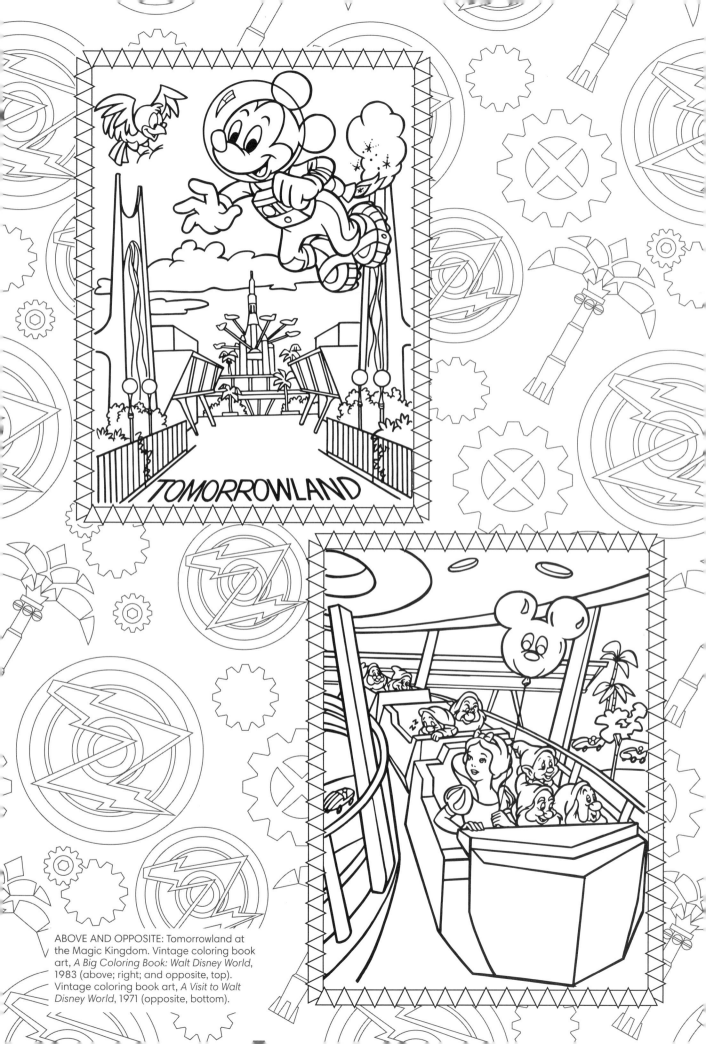

ABOVE AND OPPOSITE: Tomorrowland at the Magic Kingdom. Vintage coloring book art, *A Big Coloring Book: Walt Disney World*, 1983 (above; right; and opposite, top). Vintage coloring book art, *A Visit to Walt Disney World*, 1971 (opposite, bottom).

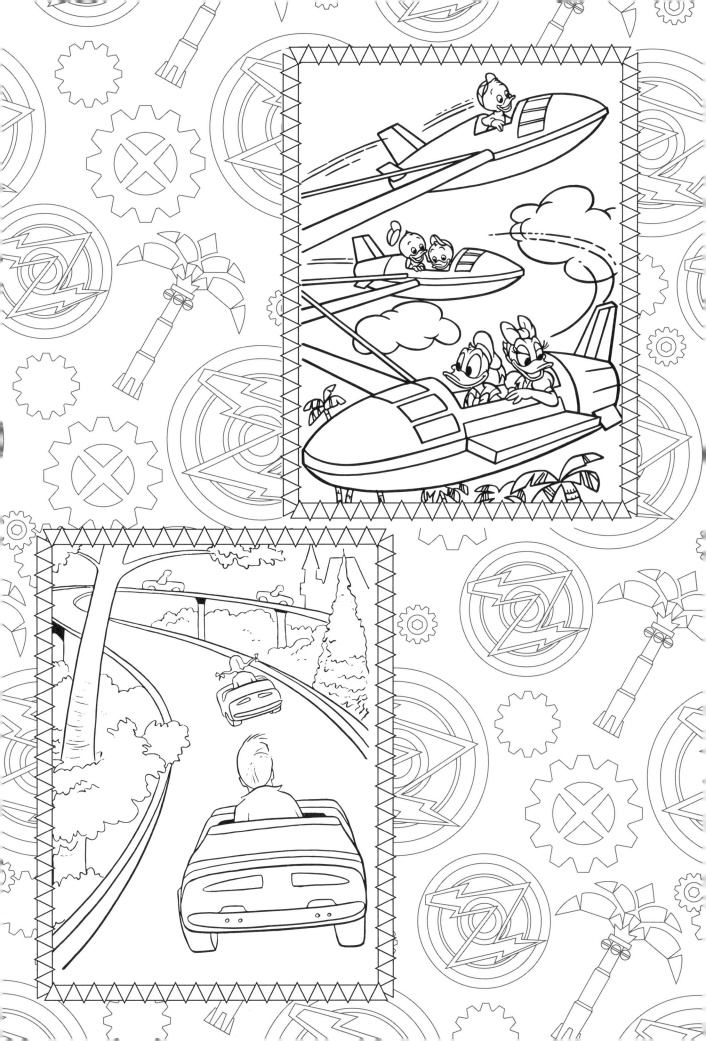

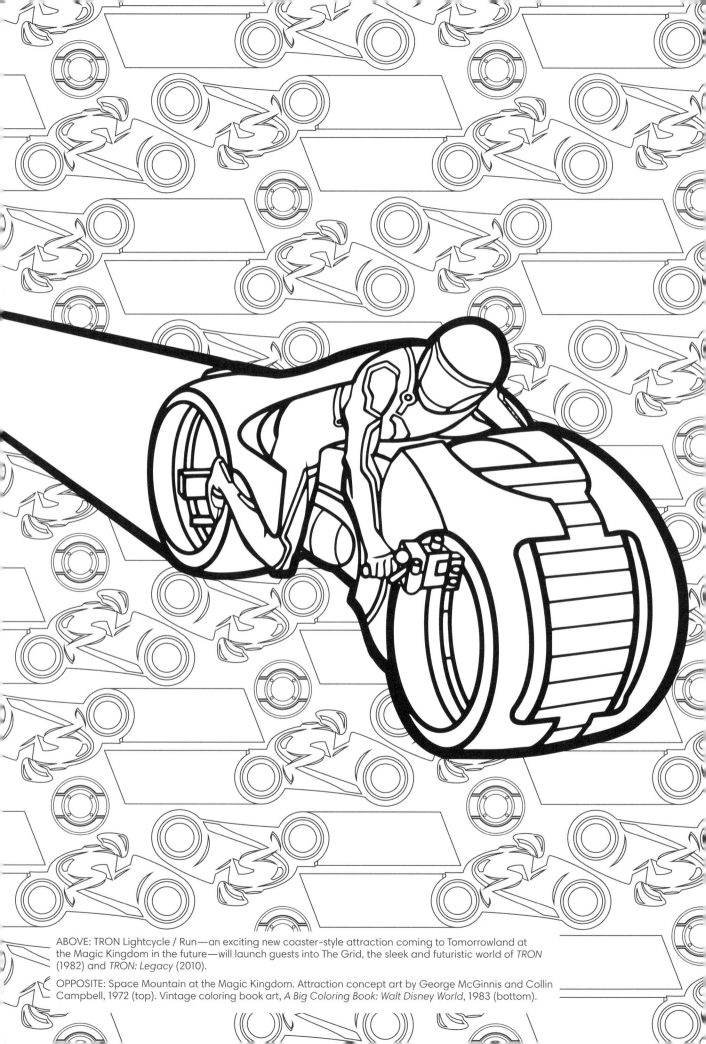

ABOVE: TRON Lightcycle / Run—an exciting new coaster-style attraction coming to Tomorrowland at the Magic Kingdom in the future—will launch guests into The Grid, the sleek and futuristic world of *TRON* (1982) and *TRON: Legacy* (2010).

OPPOSITE: Space Mountain at the Magic Kingdom. Attraction concept art by George McGinnis and Collin Campbell, 1972 (top). Vintage coloring book art, *A Big Coloring Book: Walt Disney World*, 1983 (bottom).

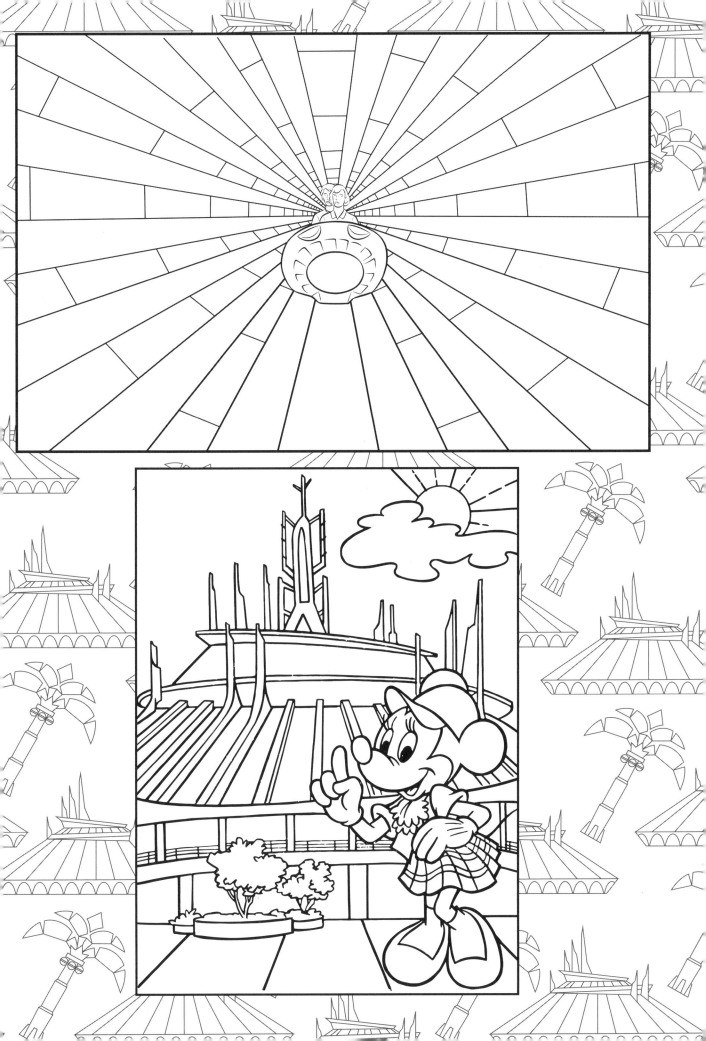

ABOVE: Selection of original EPCOT Center ticket media, 1982.

OPPOSITE: Spaceship Earth at EPCOT. Vintage publishing art, *Disney Trivia: A Family Game of Fun Facts & Fantasy*, 1984.

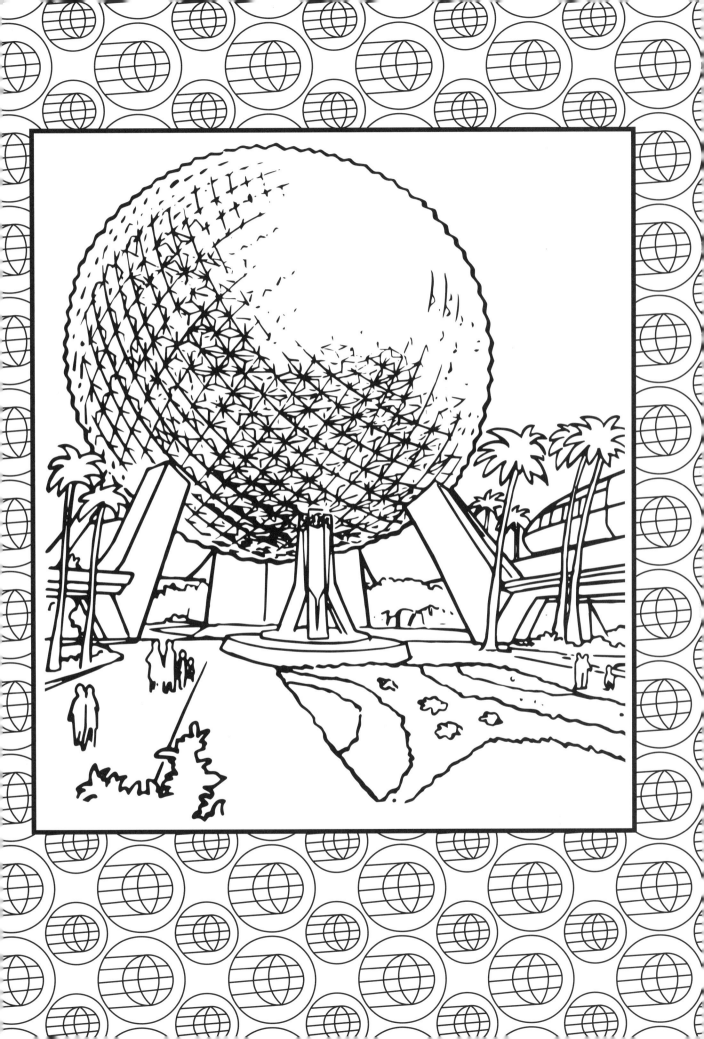

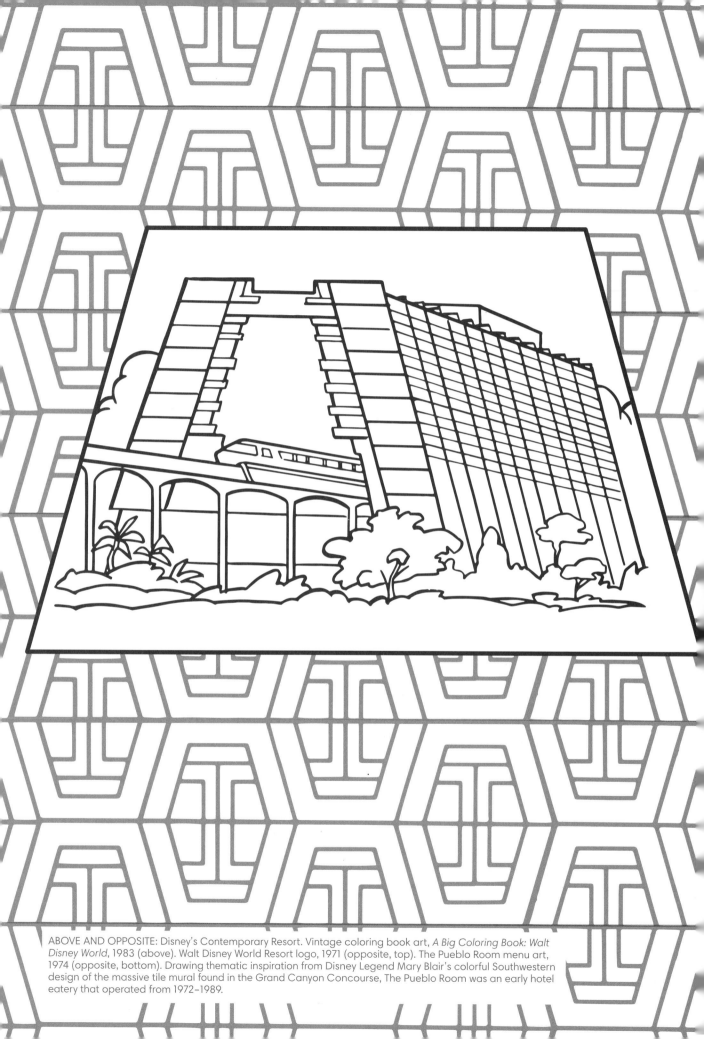

ABOVE AND OPPOSITE: Disney's Contemporary Resort. Vintage coloring book art, *A Big Coloring Book: Walt Disney World*, 1983 (above). Walt Disney World Resort logo, 1971 (opposite, top). The Pueblo Room menu art, 1974 (opposite, bottom). Drawing thematic inspiration from Disney Legend Mary Blair's colorful Southwestern design of the massive tile mural found in the Grand Canyon Concourse, The Pueblo Room was an early hotel eatery that operated from 1972–1989.

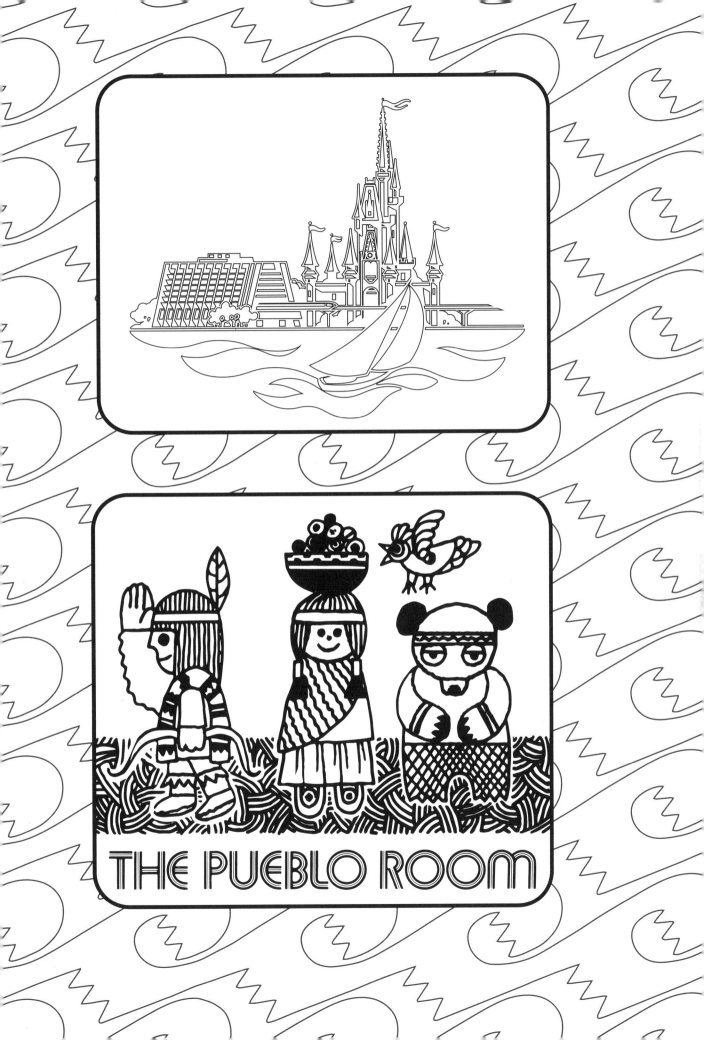

THE PUEBLO ROOM

FIVE DECADES HAVE NOW PASSED SINCE OPENING DAY, and it should be easy to see that what has continued to grow here in Central Florida is nothing short of the fulfillment of an American dream. From Walt Disney's earliest concepts for the property in the mid-1960s to the unmatched hospitality and storytelling found at the resort today, Walt Disney World has continued to shine on as a unique beacon of innovation and intensely thematic artistry.

> Walt Disney World is a tribute to the philosophy and life of Walter Elias Disney . . . and to the talents, the dedication, and the loyalty of the entire Disney organization that made Walt Disney's dream come true. May Walt Disney World bring Joy and Inspiration and New Knowledge to all who come to this happy place . . . a Magic Kingdom where the young at heart of all ages can laugh and play and learn—together.
>
> —Roy O. Disney, resort dedication, October 25, 1971[R.1]

By providing a forum of entertainment and joy for families and individuals of all ages to experience and appreciate the cultures and magic of the world around them, Walt Disney World has served its central purpose countless times over for those who have visited, each time providing new memories to cherish. Let us now toast the amazing legacy of Walt's fabled "Florida Project," itself a bastion of inspiration that has undeniably left its mark on popular culture.

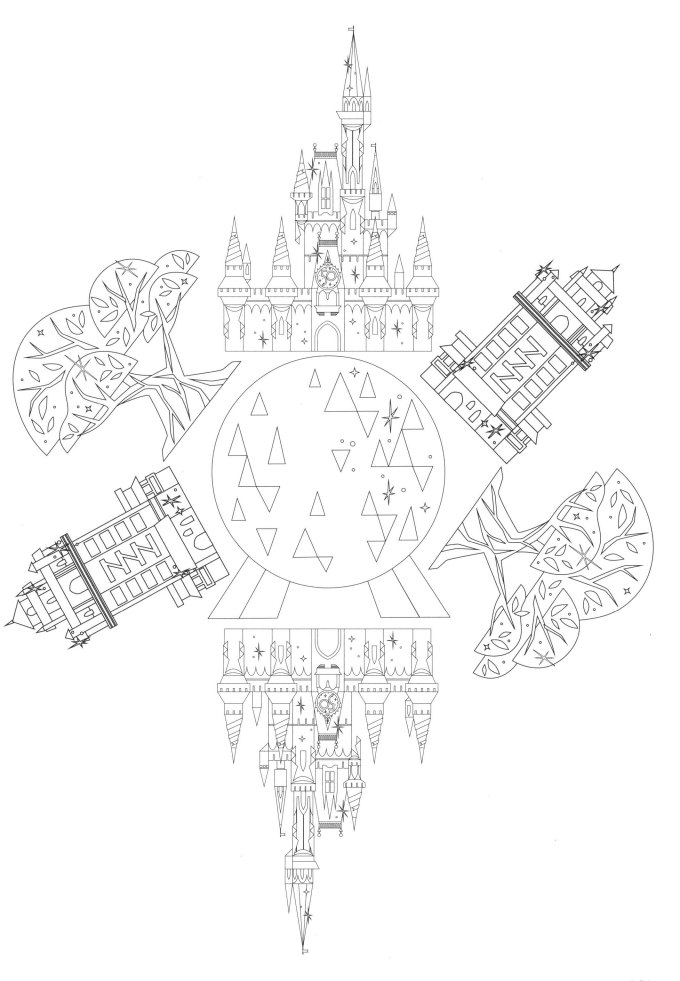

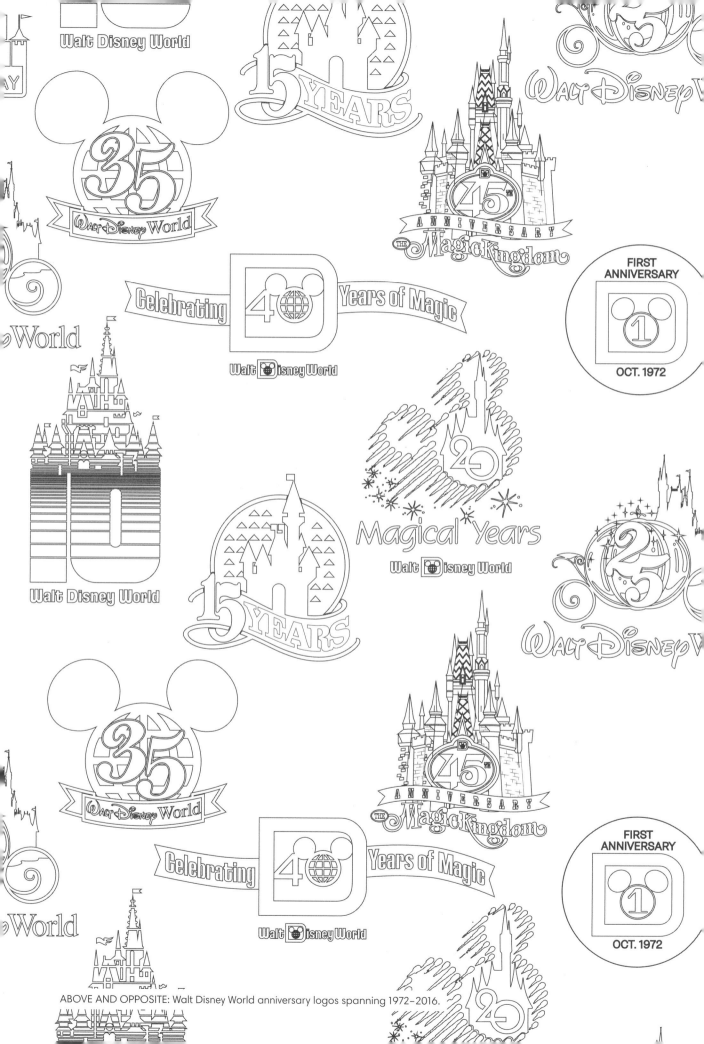

ABOVE AND OPPOSITE: Walt Disney World anniversary logos spanning 1972–2016.

OPPOSITE: Aerial caricature map of resort by Paul Hartley, *Preview Edition Walt Disney World* brochure, 1970.

ABOVE AND OPPOSITE: Preopening logo and merchandise design artwork, c. 1970.

OPPOSITE: Caricature fun map by Paul Hartley, Magic Kingdom, 1971.

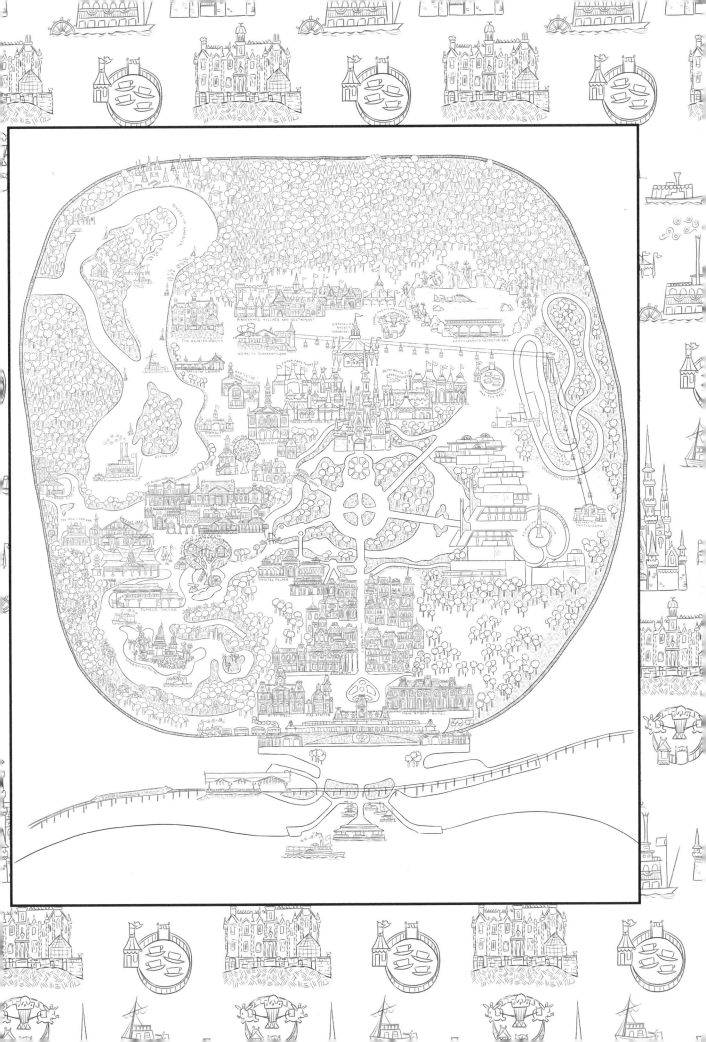

OPPOSITE: Fun map by a Disney studio artist, EPCOT Center, 1981.

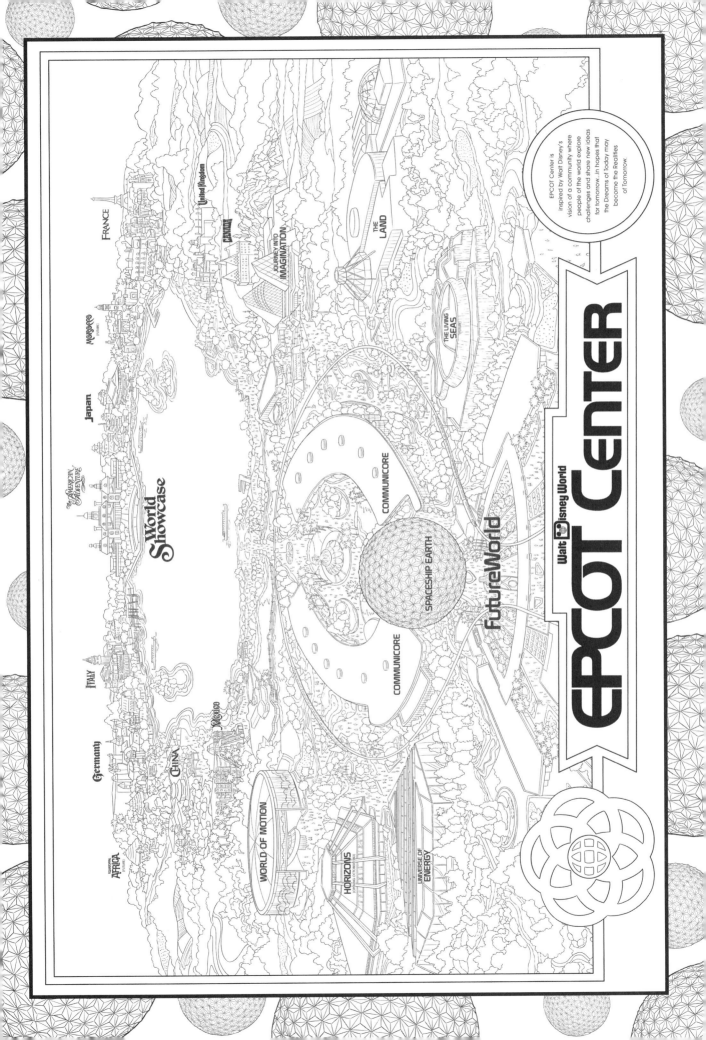

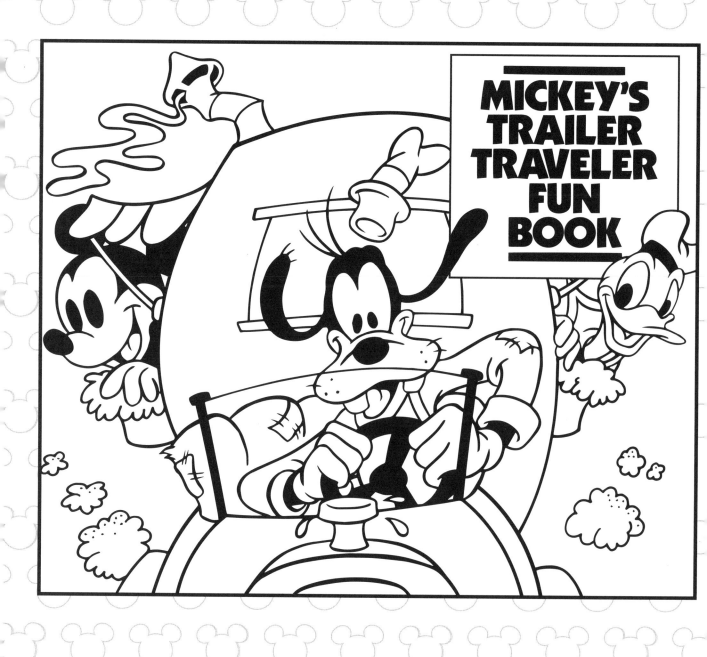

ABOVE AND OPPOSITE: Originally available at the Disney Information Center in Ocala, Florida, *Mickey's Trailer Traveler Fun Book* (1987) helped scores of young resort guests pass time on the road to and from Walt Disney World. Cover art by Russell Schroeder (above). Activity map by Don Williams (opposite).

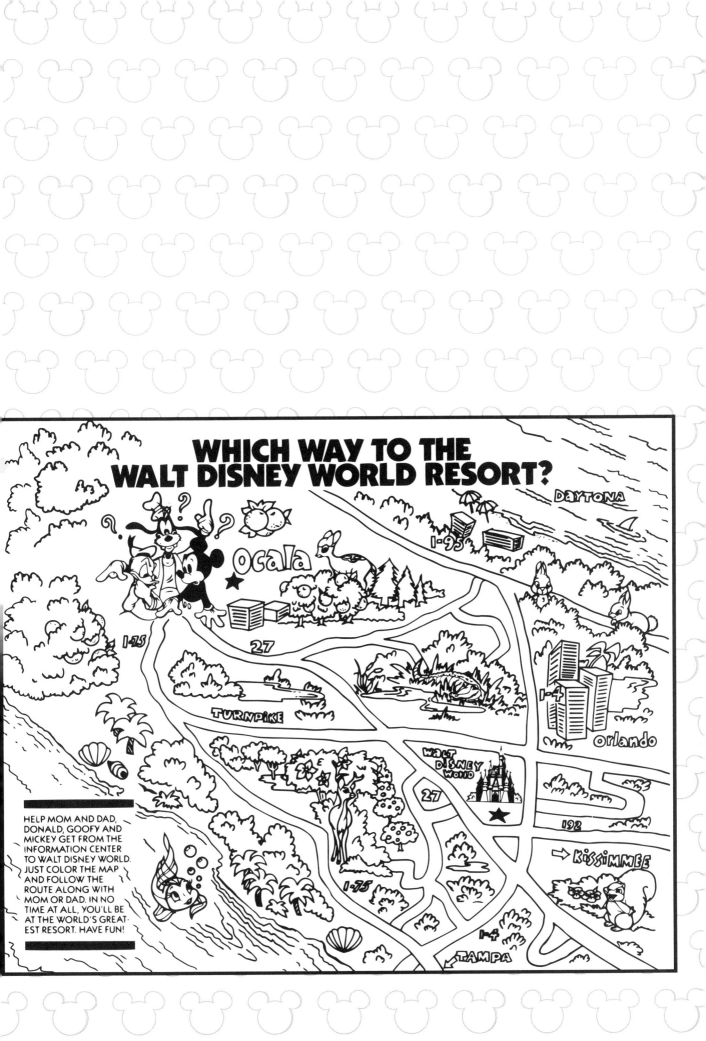

THE WORLD'S MOST MAGICAL CELEBRATION
THE FIFTIETH ANNIVERSARY OF WALT DISNEY WORLD

FIFTY YEARS OF MAGIC, MEMORIES, AND MYRIAD milestones have now inspired numerous generations of Walt Disney World guests. Building on an already-rich foundational legacy, the future of the resort is bright and should be embraced while looking through the spyglass of history with much anticipation. Given all that has been accomplished during the first fifty years, who knows what's possible next?

It's also the perfect place and time to celebrate the small stuff, the big stuff, and even the in-between stuff that has always made the resort so special—because when we embrace the magic of Walt Disney World, nothing could be more powerful. As The World's Most Magical Celebration beckons all to join in on the fun, the timelessness and wonder found at the resort will continue to shine on for each of us, from inspirational spark to finely polished sparkle.

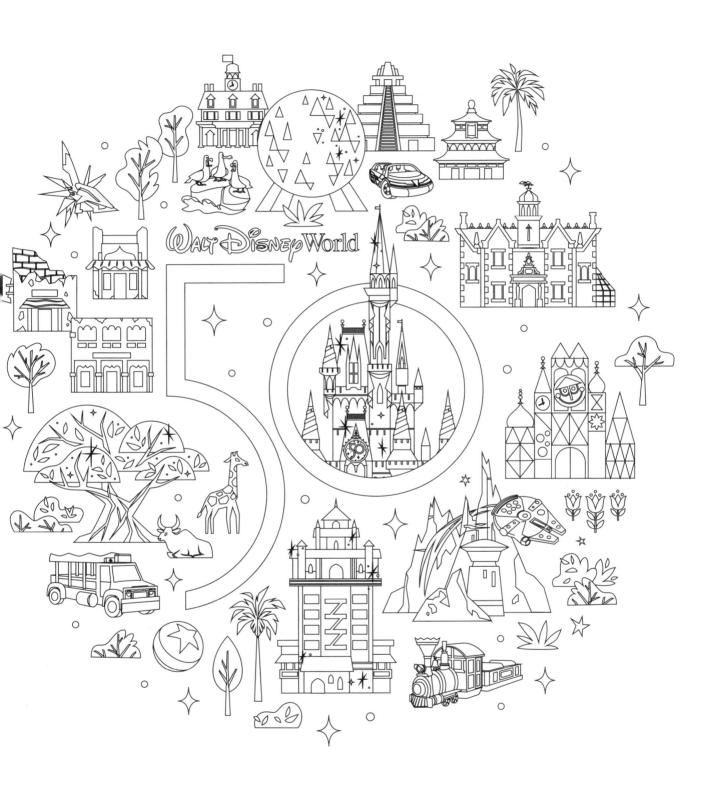

ABOVE AND OPPOSITE: A medley of Walt Disney World icons.

ABOVE: Memorable characters from across The Walt Disney Company join the celebration.

OPPOSITE: The *Partners* statue is located just in front of Cinderella Castle at the Magic Kingdom. Featuring Walt Disney and Mickey Mouse, it was sculpted by Disney Legend Blaine Gibson.

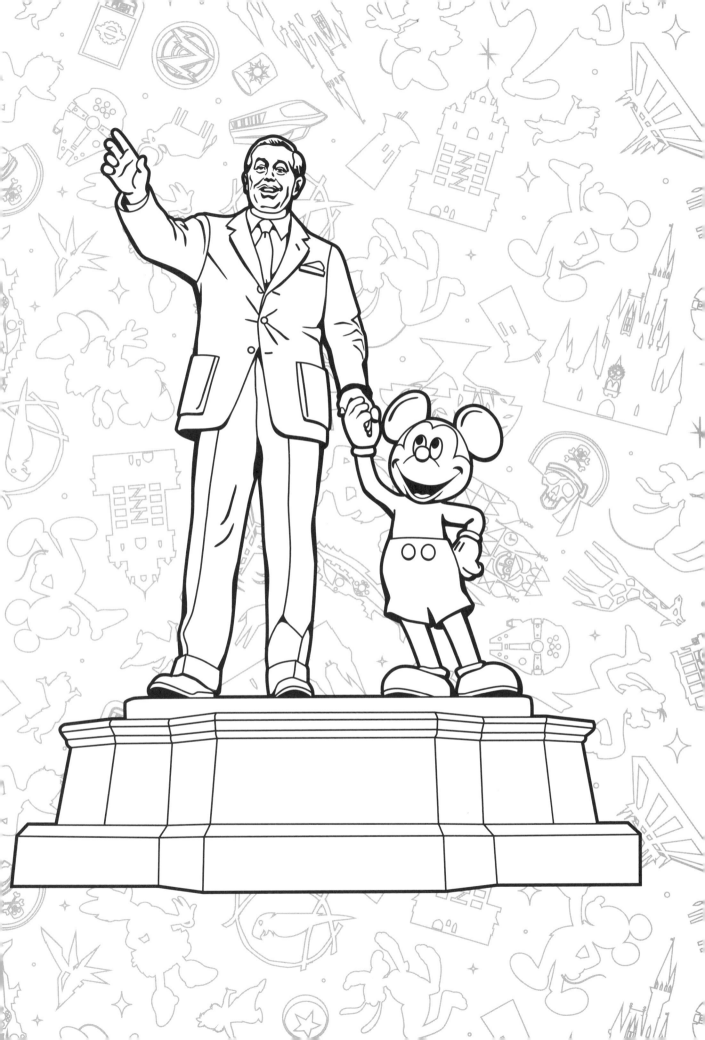

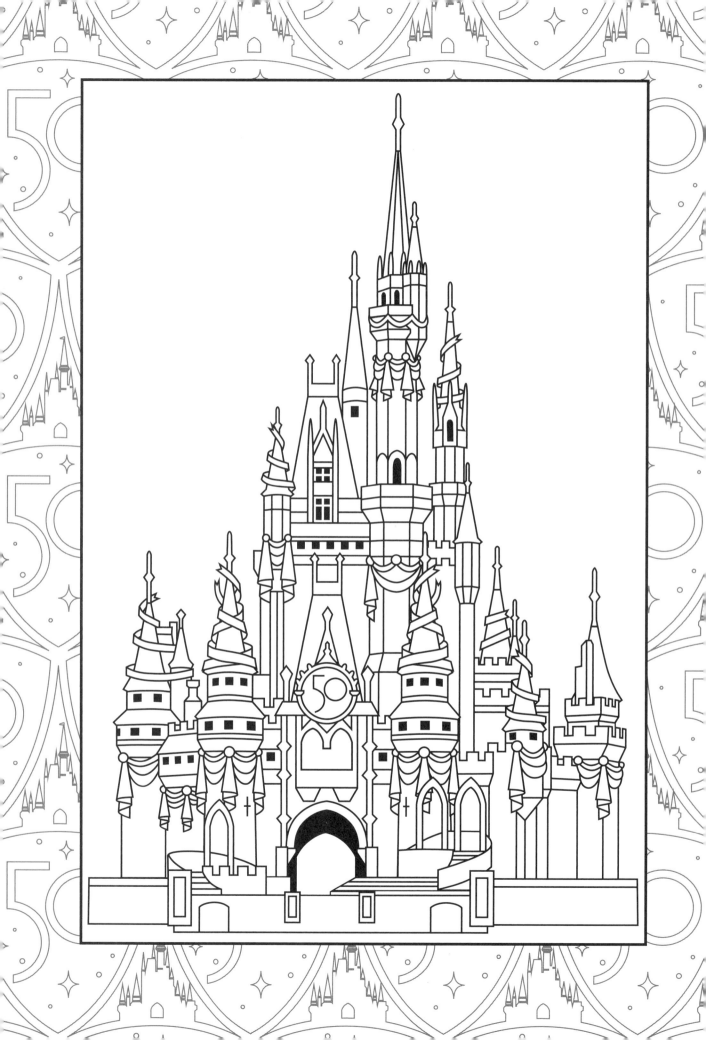

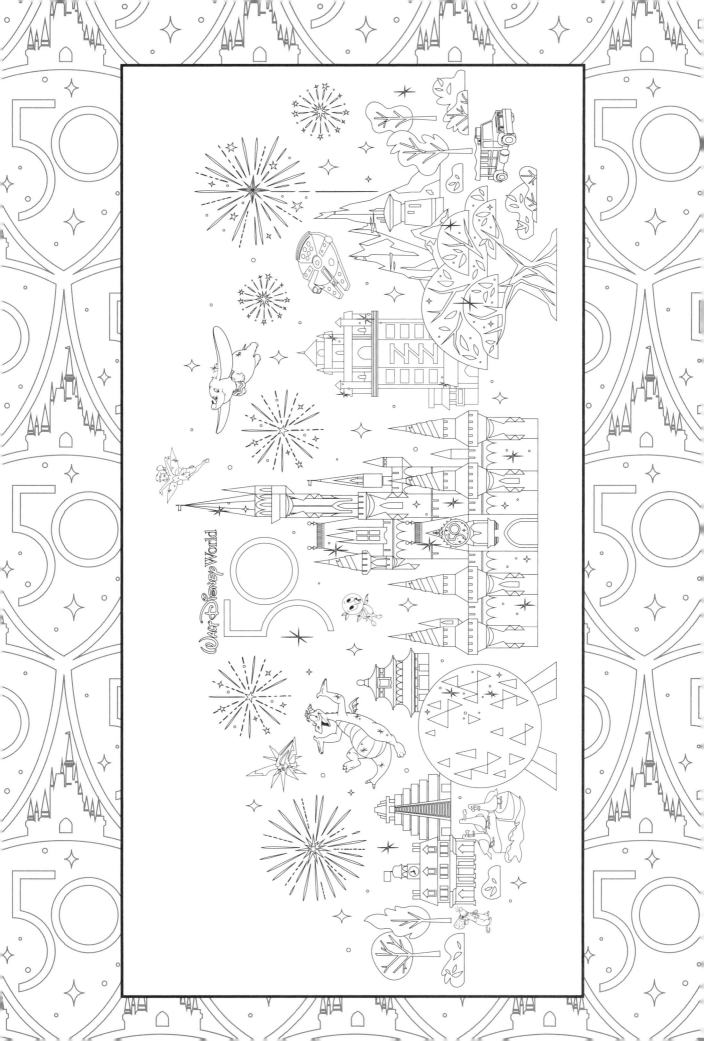

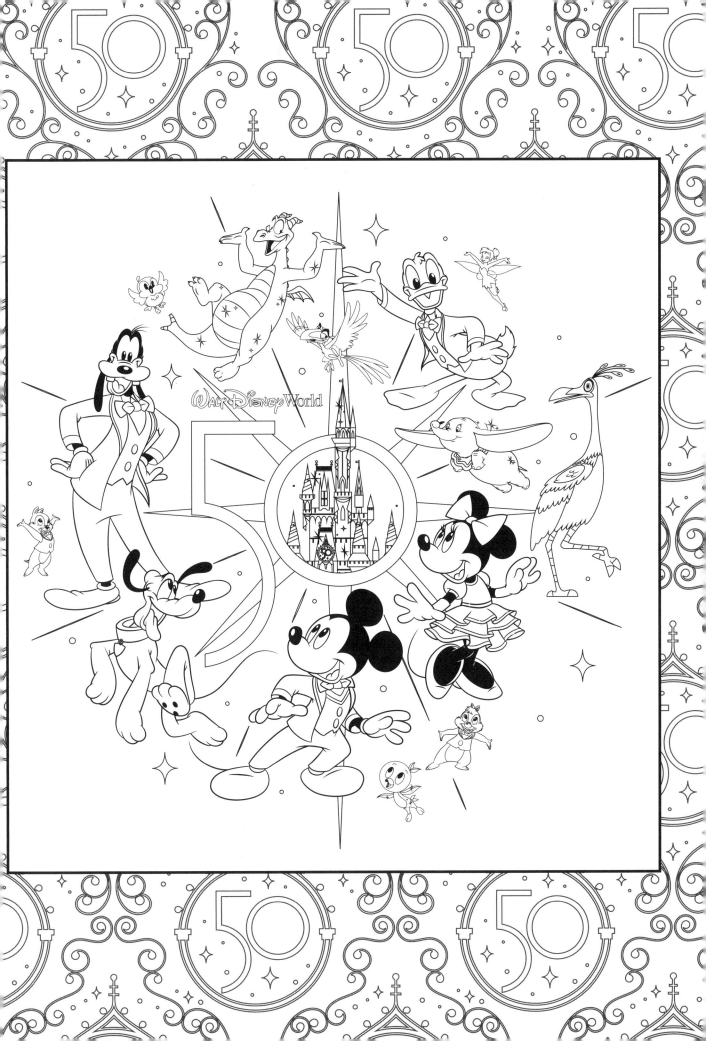

P.1. Disney, Walt; as found in Smith, Dave. *The Quotable Walt Disney* (2001, Disney Editions, New York), p. 134.

N.1. Disney, Walt; as found in Smith, Dave. *The Quotable Walt Disney* (2001, Disney Editions, New York), p. 173.

N.2. Sklar, Marty. *One Little Spark! Mickey's Ten Commandments and The Road to Imagineering* (2015, Disney Editions, New York), p. 64.

F.1. Disney, Walt; as found in Smith, Dave. *The Quotable Walt Disney* (2001, Disney Editions, New York), p. 249.

F.2. Rawlins, Pam; as quoted in Ashley, Deidra. "A new fantasyland of LIVING ART," *Walt Disney World Eyes & Ears*, 10/31–11/13/2013, Vol. 43, Number 22, p. 4.

D.1. Disney, Walt; as found in Smith, Dave. *The Quotable Walt Disney* (2001, Disney Editions, New York), p. 163.

D.2. Smith, Carmen; as quoted in Ramirez, Michael. "New Adventures to 'Cast' Off Soon Along World-Famous Jungle Cruise at Disneyland Park and Magic Kingdom Park," *Disney Parks Blog*, 01/25/2021.

T.1. Disney, Walt. *Dateline Disneyland*, American Broadcasting Company. Airdate: 07/17/1955 (Walt Disney Archives).

R.1. Disney, Roy O. Dedication plaque, Magic Kingdom, Walt Disney World Resort, 1971.

X.1. Sklar, Marty. *Dream It! Do It! My Half-Century Creating Disney's Magic Kingdoms* (2013, Disney Editions, New York), p. 2.

ABOVE: Captain Hook character art, *Mickey & Friends Coloring Book: Walt Disney World*, 2013 (top). Ludwig Von Drake character art, *Disney Trivia: A Family Game of Fun Facts & Fantasy*, 1984 (bottom).

OPPOSITE: Vintage Walt Disney World luggage tag, 1990.

ACKNOWLEDGMENTS

No creative enterprise is ever truly the work of one person, and the pages assembled before you are no exception. This book would not have been possible without the generous contributions of the following groups from across The Walt Disney Company:

Walt Disney Archives

Walt Disney Imagineering

Yellow Shoes Marketing Resource Center

THE AUTHOR AND THIS BOOK'S PRODUCERS WOULD LIKE TO SPECIALLY THANK:
Justin Arthur, Kelly Bigler, Summer Bloomfield, Pam Brandon, Holly Brobst, Denise Brown, Michael Buckhoff, Nicole Carroll, Becky Cline, Jim Cora, Alyce Diamandis, Lynne Drake, the Eastwood family, Jeffrey R. Epstein, Maggie Evenson, Chelsea Fallon, Fabiola Garza, Jeff Golden, Vanessa Gonzales, Howard Green, Don Hahn, Kathleen Hill, Vanessa Hunt, Michael Jusko, the Kern family, Aileen Kutaka, Gary Landrum, Charles Leatherberry, Kevin Lively, Ryan March, Robert Maxhimer, Matt Moryc, Zenia Mucha, John Musker, Nikki Nguyen, Tim O'Day, Amy Opoka, Chris Ostrander, Ed Ovalle, Christina Pappous, Diego Parras, Ty Popko, Joanna Pratt, John Raymond, Cody Reynolds, Russell Schroeder, Francesca Scrimgeour, Stacy Shoff, Marty Sklar, Dave Smith, Marcy Carriker Smothers, David Stern, Lauren Thomas, the Thomas family, Kimi Thompson, Janice Thomson, Melody Vagnini, Steven Vagnini, Julia Vargas, Michael Vargo, Cayla Ward, Alex Williams, Don Williams, Kelsey Williams, Mindy Wilson Fisher, Juleen Woods, and the entire cast of the Walt Disney World Resort.

ALSO, THANK YOU TO THE DISNEY EDITIONS TEAM:
Wendy Lefkon, Jennifer Eastwood, Lindsay Broderick, Monica Vasquez, Jerry Gonzalez, and Marybeth Tregarthen.

AND TO THOSE AT DISNEY PUBLISHING: Seale Ballenger, Jennifer Black, Elena Blanco, Max Calne, Jennifer Chan, Alicia Chinatomby, Monique Diman, Terry Downes, Michael Freeman, Alison Giordano, Tyra Harris, Winnie Ho, Lyssa Hurvitz, Jasmine Hu, Molly Jones, Jackson Kaplan, Vicki Korlishin, Kim Knueppel, Renee Leask, Meredith Lisbin, Warren Meislin, Lia Murphy, Kori Neal, Scott Piehl, Dominque Pietz, Tim Retzlaff, Rachel Rivera, Danny Saeva, Andrew Sansone, Zan Schneider, Fanny Sheffield, Ken Shue, Annie Skogsbergh, Megan Speer-Levi, Jenny Spring, Sara Srisoonthorn, Muriel Tebid, Pat Van Note, Elke Villa, Lynn Waggoner, Jessie Ward, and Rudy Zamora.

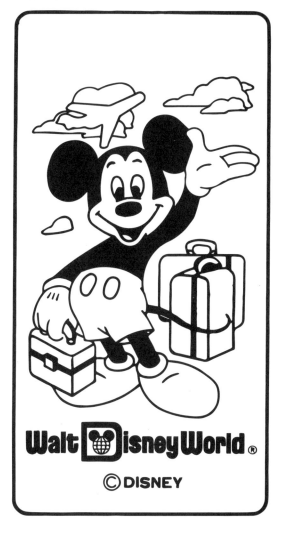

VINTAGE COLORING VIGNETTES FROM PAST PUBLICATIONS: *A Visit to Walt Disney World,* **1971**—in the "Nostalgia" chapter, pages 12, 13, 14, and 22; in the "Fantasy" chapter, page 33; in the "Discovery" chapter, pages 59 (top) and 84. • *Big Albert Moves In,* **1971**—in the "Nostalgia" chapter, page 24. • *Walt Disney World Coloring Book,* **1972**—in the "Nostalgia" chapter, page 20; in the "Discovery" chapter, page 62; and in the "Tomorrow" chapter, page 93 (bottom). • *A Big Coloring Book: Walt Disney World,* **1983**—in the "Nostalgia" chapter, pages 15, 16, and 18; in the "Fantasy" chapter, pages 32 and 36; in the "Discovery" chapter, pages 59 (center and bottom); and in the "Tomorrow" chapter, pages 92 (top and bottom), 93 (top), 95 (bottom), and 98. • *A Coloring Book: Walt Disney World EPCOT Center,* **1983**—"Preface" pages 6-7 (border); in the "Nostalgia" chapter, page 19; in the "Fantasy" chapter, pages 39 (top, center, and bottom), 40, and 41; and in the "Discovery" chapter, pages 64 (top and bottom), 68 (top, center, and bottom), and 69 (top, center, and bottom). • *Disney Trivia: A Family Game of Fun Facts & Fantasy,* **1984**—in the "Tomorrow" chapter, page 97 and "Bibliography and Endnotes" page 124 (bottom). • *Mickey's Busy Book,* **c. 1986**—"Contents" page 4. • *Mickey's Trailer Traveler Fun Book,* **1987**—in the "Reflections" chapter, pages 112 and 113. • *A Giant Coloring Book: Walt Disney's Disneyland,* **1991**—in the "Nostalgia" chapter, page 25 (top, left and right, and bottom, left and right). • *A Giant Coloring Book: Walt Disney World,* **1991**—in the "Discovery" chapter, pages 58 and 63 (bottom). • *Mickey & Friends Coloring Book: Walt Disney World,* **2013**—in the "Discovery" chapter, page 70 (Figment) and "Bibliography and Endnotes" page 124 (top).

PRESENT-DAY COLORING VIGNETTES BY THE DISNEY STORYBOOK ART TEAM: In the "Fantasy" chapter, pages 34, 37, 38, 42, 43, and 46; in the "Discovery" chapter, page 65, 86-87 (tennis); and in the "Tomorrow" chapter, page 94.

COURTESY THE WALT DISNEY ARCHIVES: Ephemera and product reference for pages 1 and 2; "Contents" pages 4 (background) and 5 (border); "Preface" page 7 (compass); in the "Nostalgia" chapter, pages 12 (background), 20 (center), 24 (center), and 27; in the "Fantasy" chapter, page 54; in the "Discovery" chapter, pages 58 (center), 62 (center and background), 63 (top, center, and bottom), 83, and 85 (map); in the "Tomorrow" chapter, pages 93 (bottom), 96, 98 (background), and 99 (all); in the "Reflections" chapter, pages 102–103 (all), 106–107 (all), 112, and 113.

COURTESY THE WALT DISNEY IMAGINEERING ART COLLECTION: In the "Nostalgia" chapter, art reference for pages 16 ("CP" in the border), 17, 20 (background), 21, and 23 and logo reference for background on page 19; in the "Fantasy" chapter, art references for pages 31 and 35 (all) and logo references for backgrounds on pages 38, 39, 40-41, and 42; in the "Discovery" chapter, art references for pages 61 and 63 (background) and logo references for backgrounds on pages 64, 66, 67, 68-69, and 70; in the "Tomorrow" chapter, art references for pages 90, 91, and 95 (top) and logo reference for background on page 97; in the "Reflections" chapter, art references for pages 104, 105, 106, 107, 108, and 109; and "A Blank Page" (opposite, header art).

COURTESY THE WALT DISNEY IMAGINEERING PHOTO COLLECTION: In the "Fantasy" chapter, photo reference for page 30 (all) and, in the "Discovery" chapter, photo reference for pages 77 and 80-81.

COURTESY THE YELLOW SHOES MARKETING RESOURCE CENTER: In the "Fantasy" chapter, photo reference for page 45 (marquee) and 47 (queue poster) and art reference for page 55; in the "Discovery" chapter, art references for pages 72-73, 82 (Disney Springs logo and water tower silhouette), and 87 (map).

COURTESY THE DISNEY CONSUMER PRODUCTS CREATIVE DESIGN TEAM: The front cover and page 3; "Preface" pages 8-9; in the "Nostalgia" chapter, pages 11, 16 (filigree border), 25 (background), 26, 27 (background); in the "Fantasy" chapter, pages 29, 34 (background), 43 (background), 45 (background), 48, and 49 (background); in the "Discovery" chapter, pages 57, 58 (background), 60, 66 (top and bottom), 67 (vehicles), 70 (*The Aristocats*/painting), 71, 73 (*Ratatouille*), 74, 75, 76, 78-79, 82 (Mickey and Minnie and background), and 86-87 (soccer, running, volleyball, baseball, football, and basketball); in the "Tomorrow" chapter, pages 89, 92-93 (background), 94 (background), and 95 (background), in the "Reflections" chapter, page 101; and in "The World's Most Magical Celebration" chapter, pages 115, 116, 117, 118, 119, 120, 121, 122, and 123.

COURTESY DISNEY TELEVISION ANIMATION: In the "Fantasy" chapter, page 44 (character art from *Mickey Mouse,* 2013-2019).

COURTESY LUCASFILM LTD.: In the "Fantasy" chapter, pages 50-51, 52, and 53.

COURTESY THE KERN FAMILY COLLECTION: In the "Fantasy" chapter, product reference for page 49 (coin); in the "Discovery" chapter, ephemera reference for page 85 (masthead); and product reference for "Acknowledgments" page 125 (luggage tag).

OPPOSITE: "There are two ways to look at a blank sheet of paper. . . . It can be the most frightening thing in the world, because you have to make the first mark on it. Or it can be the greatest opportunity in the world, because you get to make the first mark—you can let your imagination fly in any direction, and create whole new worlds!"

—Disney Legend Marty Sklar[X.1]